MILNER CRAFT SERIES

FOLK ART OF FRANCE

Décor Folklorique

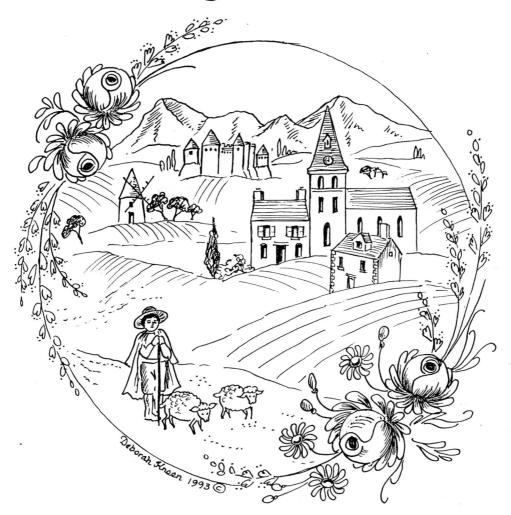

DEBORAH KNEEN

SALLY MILNER PUBLISHING

First published in 1993 by
Sally Milner Publishing Pty Ltd
558 Darling Street
Rozelle NSW 2039
Australia

Reprinted 1993, 1994

© Deborah Kneen, 1993

Design by Wing Ping Tong
Photography by Rodney Weidland
Typeset in Australia by Asset Typesetting Pty Ltd
Printed in Australia by Impact Printing, Melbourne

National Library of Australia
Cataloguing-in-Publication data:

Kneen, Deborah.
 Folk art of France

 ISBN 1 86351 107 5.

 1. Decoration and ornament — France — Handbooks, manuals, etc. 2.
 Folk art — France — Handbooks, manuals, etc.3. Handicraft _ France
 — Handbooks, manuals, etc. I. Title. (Series: Milner craft series).

745.723

 Designs may be copied for personal use only, but not for any
commercial purposes.

Cover details: Naive scene, based on the countryside around Carcassonne.
Scene underpainted with Cream. Border of Dordogne roses, pin wheel daisies
and lavender. Background: Black Green, sponged with Medium Blue Green
and Moss Green.

This book is dedicated with love to my mother
who taught me to draw and paint.

ACKNOWLEDGEMENTS

I would like to thank all those who helped in the preparation of this book: Joyce Spencer, Jennifer Bowe and Pam Jones (who both work miracles in sourcing hard-to-get items), Gail and Jeff Dellow, Ray Ellis of Finestyle Interiors, Jeanette Gill, Suzanne Kelly (for sharing her calligraphy expertise with an undisciplined folk artist), Lynn Humphries, Lynne McKechnie, (President, Folk and Decorative Artists' Association of Australia), Jan Norris (who again most generously assisted me in researching the quotations), Frances Robinson and Wing Ping Tong.

I am indebted to Sally Milner and her expert team, including Margaret Bowman, Jenny Cattell and Lisa Hanrahan for their dedicated and enthusiastic guidance of this project.

My grateful thanks to two special people: Rodney Weidland for his beautiful photographs and fellow Francophile, Christine Whiston D'Erceville for her *avant-propos*.

A big thank you to the people who took the time to show and discuss items of French folk art, especially the curator at the Musée des Charmettes and the staff at the Musée Fabre.

To my mother, Phyll Hill and son, Brenton, for their love and support, and for holding down the fort whilst Peter and I were in France.

And, finally, to Peter, a wonderful and patient travelling companion who drove over 4000 kilometres through the back roads of France to help me find material for this book. He has encouraged and supported me at every stage.

OREWORD

France — for many the word conjures images of Parisian grandeur, of artistry and an unparalleled sense of style. Yet it is the colours of the landscape and the simple charm of this wonderful country which linger longest in the memory. A bunch of dried lavender hanging from an ancient beam, a market trestle, brilliant beneath a display of fresh produce, age-old villages that appear to defy contemporary engineering as they cling precariously to a rocky hillside — these are the lasting images of a country where a naive faience honey pot is as precious as a Limoges porcelain.

The *joie de vivre* of the people of France has long been expressed in their art. The country, it seems, inspires the painterly spirit and it has touched the pages of this book, just as it has touched the heart of its author, Deborah Kneen.

Folk Art of France pioneers new paths. Indeed, *Décor Folklorique* brings a completely new understanding to our knowledge of this age-old craft and of the importance of keeping its tradition alive by translating the motifs of the past into the brushstrokes of today.

To flip its pages is to find oneself amidst the hills of Provence, in the narrow streets of a village in the Dordogne, or surrounded by Monet's glorious garden at Giverny. *Folk Art of France* documents the regional and stylistic diversity of French folk art.

It is a remarkable book in many ways, but most particularly because it has been written by an *étranger*. As a visitor to a country one is able to see with great clarity things the locals take for granted and, in researching this book, Deborah has put together a unique history based on traditional images and her artist's eye — a history which might well surprise the unsuspecting artists who created it all those years ago.

But *Folk Art of France* aims to do more than inspire. It is a practical book filled with projects as diverse as the countryside from which they emanate. From a pepper mill decorated with Montpellier roses to a Christmas triptych peopled with Provençal *santons*, every item it details is designed to fill your world with the ambience and beauty that is *Décor Folklorique*.

Christine Whiston
Editor-in-Chief, *The Australian Country Craft Series.*

CONTENTS

Projects to Paint

Useful Information

LIST OF COLOUR PHOTOGRAPHS
AND WORKSHEETS

ACCESSORIES

(unless stated otherwise, all from the author's personal collection)
Page 73: A. Gibert fruit plate, 1873, Paris, (courtesy of Joyce
Spencer) and contemporary Moustiers faience herb canisters,
Provence; Page 75: tapestry fabric (courtesy of Finestyle Interiors),
hand carved and painted statue of Saint Marc and his lion,
Rocamadour, Périgord; page 79: old French laces (courtesy of
Joanne Hill), Limoges porcelain portrait brooch, c. 1920; page 80:
antique Sarreguemines cheese plate, Alsace (courtesy of Joyce
Spencer); Page 97: part of a large collection of old French coffee
cups; Page 103: large contemporary terracotta shepherd *santon*,
Aigues-Mortes.

PREFACE

My love of things French goes back many years. As a young school-girl, I began the study of French language and culture and would later visit France, first as a university student and then as a high school languages teacher.

In researching this book, I returned again to France, this time to experience the country from a new and exciting perspective which would combine my background in French with a passion for folk and decorative art. I visited local museums and historic buildings in towns and villages across France, seeking out the folk art designs of the 17th, 18th and 19th centuries. What a wealth of beautifully painted functional pieces I found: furniture, tiles, vases, tureens, plates, bowls and other utensils. I will never forget the charm and courtesy of the people of provincial France, in the remote alpine villages of Savoie-Dauphiné, the Roman towns and walled cities of the south, the mediaeval clifftop villages of the Dordogne and Périgord, the Renaissance towns of the Loire valley and so many other interesting places.

In this book I aim to share with you my interpretations of traditional French country designs. The book does not attempt to present a comprehensive study but rather a personal sampling, based on my research and travels. It is the first time a book devoted to French rustic motifs has been compiled for folk art enthusiasts.

The early sections deal with the history of French painted decoration, both sophisticated and rustic, followed by an analysis of regional floral motifs. The projects section presents country collectables, decorated with French-inspired designs.

Join me on this folk art journey across France to explore the world of *décor folklorique*. You will find that it is an almost limitless source of inspiration for the contemporary folk artist.

Bonne peinture!

Deborah

Though we travel the world over to find the beautiful,
we must carry it with us or we will find it not.

Ralph Waldo Emerson (1803-1882)

NTRODUCTION

When the term 'folk art' is mentioned, most people think of German-speaking Europe. And it is true that some of the finest and certainly the most abundant examples of folk art on wood can be found in Germany, Austria and Switzerland.

But we tend to forget that the French, too, have a strong tradition of folk painting, their favourite functional surface being ceramics.

REGIONAL AND STYLISTIC DIVERSITY

France boasts a wide diversity of regional folk art styles, reflecting the distinct geographical differences of the country itself. Landscapes vary from the high alps in the east to the warm hills, olive groves and marshes of the Mediterranean. Similarly, in folk art, the sombre German-influenced black and red designs of Alsace near the Rhine are in complete contrast to the vibrant yellow and cobalt blue florals of the sunny south.

Beyond the realm of rustic painting, France is famed for its elegant decorative painting on a range of functional surfaces. Think of the beautiful rococo furniture of the 18th century adorned with painted floral garlands, cherubs and idyllic pastoral scenes, or the palace at Versailles with its decorated walls and ceilings. And let us not forget the exquisite painted porcelain of Sèvres, Vincennes and Limoges.

DEFINING DECOR FOLKLORIQUE

L'art est au plus haut degré quand il est pris pour la nature même.

Jean-Auguste-Dominique Ingres (1780-1867)

(Art is at its ultimate when it most resembles nature itself.)

Ingres espoused a sophisticated and realistic style of art which is basically the preserve of the fine artist rather than the folk artist. Such methods of painting are known as *haut style*.

By contrast, most of the motifs and designs of French rustic painting are not realistic. They represent a folk artist's joyful impressions of the world, characterised by a carefree disregard for the rules of conventional art. I have dubbed this rustic country style of French painted decoration *décor folklorique*, literally, folk art decoration. Where does *haut style* end and *décor folklorique* begin? In terms of subject matter, motifs are often shared. For example, cherubs and harlequins *(pierrots)*, popular 18th century subject matter in *haut style*, painted by artists such as Watteau (1685-1721) and Boucher (1703-1770), also appear in rustic designs, albeit more naively rendered.

The two styles share such flowers as roses, anemones, lilies, iris, pansies, tulips, daisies and carnations. But it is interesting to note that, while the elegant lily and iris are popular in *haut style*, they are less common in rustic designs. The humble daisy, a mainstay of *décor folklorique*, occurs less frequently in sophisticated designs where it tends to be replaced by chrysanthemums, dahlias and anemones. Roses remain universally popular.

A semi-naturalistic folk art rose from Strasbourg, for instance, is not far removed from its more refined counterpart at Sèvres or from the rose garlands on French rococo furniture. At these times it is difficult to know where to draw the line, but the following broad criteria may help to define the scope of this book.

Décor folklorique should be:

■ painted by hand, whether naively rendered by local people and hobbyists, untrained in formal artistic skills, or, as is more often the case, undertaken by skilled artisans.

■ painted on a functional surface: *objets domestiques* or *trouvailles* (found objects) such as furniture, utensils, ceramics, tin, and so on.

■ related to the traditions and culture of its region, whether the style be *à l'ancienne* (of the past) or a modern adaptation. It is an *art populaire*, an art of the common people and the countryside.

■ composed of stylised rather than realistic motifs. They may well be quite naive and/or primitive in style and execution.

We are not dealing here with the style described by Ingres: the photographically real art of trompe l'oeil, the botanically accurate roses of artists such as Redouté, the still-life flowers and fruit of Sèvres and Limoges porcelain.

In *décor folklorique*, a rose can be any colour you desire, even cobalt blue! One plant could well bear several different types of leaf. Three or four different species of flower may appear from the one stem: all in all, a genre of fantasy bouquets.

And the fantasy element is not restricted to flowers. People themselves are often depicted in a whimsical, almost grotesque manner, hence their technical name: *personnages grotesques*. These figures are farmers, hunters, soldiers, harlequins and travelling musicians, populating a landscape where flowers and leaves grow larger than people. It is a world filled with quaint, tumbling-down cottages and crudely painted, elongated trees.

Montpellier Early C18th (tile)

FOREIGN INFLUENCES

Décor folklorique does not exist in isolation. It shares many elements with other European folk art forms, and cultural influences have flowed in both directions.

For instance, there are Italian and Spanish rustic influences in the decorative motifs of Mediterranean France, particularly the use of blue and white and of *grisaille* (grey tones). On the other hand, in Savoie (which did not become part of France until the 18th century), the style is evocative of Italy and Switzerland. In the north-east on the German border, the folk art of Alsace and Lorraine is more German than French, mirroring the chequered political history of this long-disputed region.

The 17th and 18th centuries also saw the arrival en masse in Europe of porcelain from the Far East. This oriental design influence filtered through to virtually every level of painted decoration. In the faiences of Rouen, Moustiers and Marseilles, for example, we see naively depicted exotic flowers, birds, temples, pagodas and stereotypical oriental figures with Chinese hats and long moustaches. Similarly, the *fleurs au naturel* from Strasbourg have much in common with the floral designs of Chinese porcelain. And so on.

Chinese influence in faience design from Lorraine. Late C18th

Décor folklorique is a real pot pourri of influences and styles. The quality which draws all these disparate styles together is a delightful casual charm that is uniquely French.

History of Painted Decoration in France

France, mère des arts. (France, mother of the arts.)

Joachim du Bellay (1515-1560)

This brief history deals with both rustic and more sophisticated painted decoration. It should be remembered that they co-existed from the Middle Ages, the period when more sophisticated styles began to appear. In the 18th century, the influence of the *haut style* favoured by the French court was so pervasive that the borders between the two styles sometimes become blurred.

CAVE PAINTINGS

Since prehistoric times, man has used painted decoration to embellish his surroundings — his home, furniture and utensils. France is home to some of the world's earliest known 'folk art' in the form of Stone Age cave paintings at Lascaux and Eyzies-de-Tayac in the Dordogne region. These wall paintings of deer, wild boar, bulls and horses were rendered by Cro-Magnon hunters some 20 000 years ago.

CHURCH PAINTERS

In the Middle Ages, with the construction of the great cathedrals at Paris, Rouen, Reims, Amiens and Chartres, churches became the centre of painted decoration. Frescoes and altar screens were decorated with religious scenes, and statues carved and coloured by hand. Such painted works were undertaken by both *moines-artisans* (monastic artists) and by lay painters, usually members of guilds. These artists/artisans were the folk artists of the Middle Ages. They saw their inspiration as coming from God whom they called: *le premier maître, le meilleur artisan et la source de tous les arts au monde* (the first master, the best artisan and the source of all

Depiction of a church painter from a C15th French bible

art in the world). Magnificent examples of their work can be found in churches and museums across France.

RUSTIC STYLE

FAIENCE

In the 15th century, an essentially provincial form of ceramic art called faience developed in France. Initially influenced by Italy and Moorish Spain, it soon took on a uniquely French character. Small family-owned faience factories sprang up across France: in the northern river ports of Rouen in Normandie and Quimper in Bretagne, Moulins and Nevers in central France and Montpellier, Moustiers, Marseilles and Nîmes in the south.

Rustic designs were created on tin-glazed earthenware items such as tiles, planters, bowls, tureens, vases, apothecary and herb jars, cups and platters. The faience painters used subject matter they knew well: simple scenes of country life. Farm animals, particularly hens and roosters, were favourite motifs, painted in shades of medium to dark blue on the white ceramic background.

Just like the cave painters of pre-historic times, the faience painters celebrated their successes at the hunt with pictures of pheasants and game birds or the hunter himself. Today, naively decorated faience tiles from this era can be seen surrounding farmhouse fireplaces across provincial France. There is even a thriving contemporary industry in reproducing these items.

French faience has a strong relationship with its particular locality and era. In Marseilles, the 17th and 18th century faience featured trophies from the sea: whimsical fish and shells, evocative of the seaport itself. During the Revolutionary period, 'talking faience' (*faiences parlantes*) depicted political events and emblems. They were inscribed with humorous verses and satirical mottos and graced the sideboards of middle class French families throughout the provinces. *Faiences patronymiques* were decorated with a picture of the patron saint of the intended recipient and became special gifts to commemorate weddings, births and baptisms.

FURNITURE

From the Middle Ages, French furniture was often decorated with hand carving or, if the quality of the wood was poor, it was painted in order to cover and protect the surface beneath. Sometimes the furniture was decorated by its owners, usually with

the help of *pochoirs* (stencils). Stencils were made of parchment, oiled paper, leather or tin.

In the north-west of France, in Normandie and Bretagne, painted furniture was rare. However, Norman artisans did paint and varnish sea chests of beech and linden. On a black background, they were painted or stencilled in primary colours using simple motifs of flowers, hearts and flags.

In the north-east regions of Alsace and Savoie, red was a popular background colour, particularly for cradles. Superstition dictated that red, the colour of blood, protected the child from evil spirits. The red colour was mixed with walnut stain and cow's blood, sometimes diluted with vinegar to make a glaze which allowed the wood grain to show through. Again, decoration was simple, often stencilled and featuring symmetrical rosettes and scrolls and stylised flowers in vases.

Alsace is a rich source of painted furniture because of its vast pine forests and its German folk art influence. Houses were heavily ornamented with painted motifs, inscriptions and blessings, both inside and out. Walls, doors, beams and ceilings were all decorated. The painted designs were commonly black, but in the 18th century additional colours were introduced: vermilion, bright green, burnt sienna and azure.

Following the French Revolution, the folk artists of Alsace found a unique way of expressing their solidarity with the new republic. They painted their furniture with blue, white and red-striped backgrounds, the colours of the *tricolore* (French flag). This was a variation on the traditional technique of simulating different wood veneers (*placage*) by painting stripes of *faux* wood. Such patriotic pieces can be seen today at the Musée Alsacien in Strasbourg, but, because the colours of the stripes have faded, one has to look carefully to see the original intent.

HAUT STYLE

By the 17th and 18th centuries, French painted decoration had reached its zenith. During the reign of Louis XIV, ceilings and wood panelling were adorned with gilding. At Versailles, even the piano is decorated with gold leaf, painted cherubs and garlands of flowers and the underside of the lid is graced with a Watteau-style pastoral scene.

With the coming of Louis XV and his mistress, Madame de Pompadour, furniture was painted, varnished and edged with ornamental mouldings. Imported Chinese lacquer panels decorated screens, commodes and secretaires. The walls of Madame de

Pompadour's chambers at Versailles and Bellevue were adorned with naughty, but charming scenes by Boucher.

Madame de Pompadour was a true trendsetter and promoter of French designs. She loved the beautiful porcelain of Sèvres with its painted flowers and raised gold *cartouches* and borders. Her influence was vast — the bright pink used in the rococo rose of the 1750s and '60s was named Pompadour pink after her.

In Paris, the four Martin Brothers, master cabinet makers, invented a varnish (*vernis Martin*) which imitated oriental lacquer. This was widely used throughout Europe to finish painted and découpage furniture and smaller items such as clocks.

Throughout France, tinware was also a popular surface for painting. Painted tin items ranged from vases, bowls, pot pourri diffusers to trays, boxes and planters. They were decorated with sophisticated designs. The French term, *la tôle peinte*, meaning painted tin, was transplanted to America where it was used to describe tinware painted with folk art motifs, and often erroneously to refer to American folk art in general.

Louis XVI painted tôle (tin) pot pourri diffuser with bronze handles. (*Haut style*)

During the Napoleonic era, furniture was painted, lacquered and adorned with gold. Republican sentiments, together with the recent archaeological discoveries at Pompeii and Herculaneum, created a fervour for neo-classical designs, recalling the motifs of ancient Greece and Rome.

In the mid 19th century, during the brief Second Empire of Napoleon III, furniture was finished in black lacquer and decorated with multi-coloured flowers and encrusted with mother of pearl. The floral bouquets on Second Empire furniture were lush and beautifully executed.

French decorative painting of the 18th and early 19th centuries was so influential that the style was 'borrowed' by other countries. Across the Channel, the English called it Chippendale and incorporated both rococo and chinoiserie elements. Further afield, French flowers were adapted for use on the hand-painted trays of St Petersburg and Zhostova in Russia. French rococo motifs are in fashion again today, with roses, garlands and ribbons appearing on wallpaper and furnishing fabrics.

Jardinier: Napoleon III. Black lacquered pear wood with painted florals. (*Haut style*)

SANTONS

Meanwhile, other forms of folk art were developing in the provinces. From the 18th century in Provence, there evolved a special regional form of *décor folklorique* known as *santons* (*santouns* in Provençal dialect), meaning little saints. The *santons* are little Nativity figurines made of terracotta and painted by hand.

Santons are uniquely Provençal in character: the Virgin Mary may be painted in a shawl and dress of brightly printed floral. Joseph might be a farmer in black, wide-brimmed hat and coloured scarf. The stable will be a stone *mas* (barn) with shuttered windows and terracotta Roman tiles on the roof. Other figurines could include a local shepherd offering his sheep, the mayor with a message of welcome for the newborn, the snail merchant, the garlic seller and farm workers carrying lanterns, buckets and brooms. All these figures bring the baby Jesus little presents, the fruits of their everyday labour.

Each Provençal town still has its master *santonnier* or *santon* maker, and skills are passed from one generation to the next. Even today the *santons* are painted in the costumes of the 18th and 19th centuries.

OTHER REGIONAL FOLK ART ITEMS

In many French museums of civic and regional history, you will find rustically hand-painted items of great interest. In the Musée de Vieil Aix, for example, at Aix-en-Provence, there is a superb early 18th century painted screen with a naive depiction of town

life. The many-panelled screen is painted on both sides. It presents the procession of the *Fête Dieu d'Aix* (a local religious festival) on one side and a scene of local games and celebrations on the other.

At the Musée des Charmettes in Chambéry, country home of Jean-Jacques Rousseau, there are two painted French clocks: a grandfather with rustic blue florals and a green mantle clock with small pink roses. Wallpapers are handpainted, and there are 18th century faux finishes and simple *grisaille* garlands around the cornices. The Rousseau house presents a setting for country style folk art at its most charming.

If you visit France, take time to look for items of *décor folklorique*. Remember that they will most likely be ceramics but you may be lucky enough to discover some painted wood items such as those described above. A list of relevant museums appears on page 140.

Hanging Signs and Menu Boards

In contemporary France, folk art can be found in the most unexpected places, such as the painted signs made of wood and tin which hang outside French restaurants, inns, bakeries and other shops. Originally they were all handpainted, sometimes by the owner or by a local artist or sign writer. They would depict the specialty of the shop or perhaps a humorous representation of the title of the business. Unfortunately in these days of mass production, many such unique and charming advertisements are disappearing, to be replaced by neon and other modern signs.

Likewise, the painted menu boards which stand outside restaurants constitute folk art used as advertising. They originated in the fashionable restaurants of the Palais Royal district of 19th century Paris where artists of all abilities vied for the honour of creating an original and artistic bill of fare (see also page 86).

Les Charmettes, Jean-Jacques Rousseau's country home, Chambéry

Hanging Signs

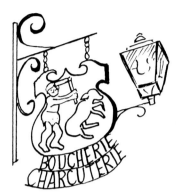

Butcher/delicatessen. Rocamadour

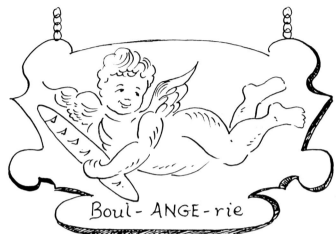

Bakery in Uzes. 'Ange' means 'angel'

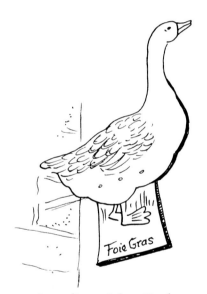

Goose liver pâté at Cordes

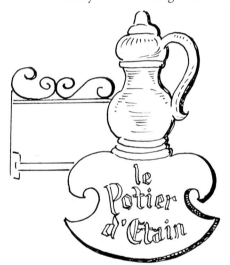

Pewter craftsman, Rocamadour

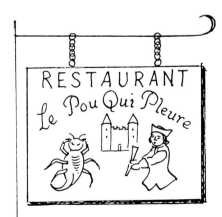

'The Mite that Cries', Restaurant, Montpellier

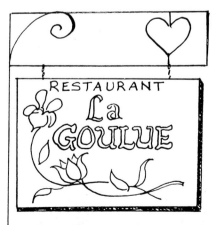

Restaurant, Aigues-Mortes. 'La goulue' means the greedy lady

BOUQUET DE FRANCE

Je vous envoie un bouquet...

Pierre de Ronsard (1524–1585)

(I send you a bouquet.)

J'offre ces violettes,
Ces lis et ces fleurettes,
Et ces roses ici,
Ces vermeillettes roses,
Tous fraîchement écloses,
Et ces oeillets aussi.

Joachim du Bellay (1522–1560)

(I offer these violets, lilies, small flowers and these roses here, these red roses, freshly blooming, and carnations, too.)

ROSES ACROSS FRANCE

Allons, cueille, cueille,
Les roses, les roses,
Roses de la vie, roses de la vie...

Raymond Queneau

(Go, pick, pick, roses, roses. Roses of life, roses of life...)

Roses have long been the favourite flower of both fine and folk artists, and it is worth remembering that there are as many

different styles of rose as there are artists. Therefore, it is not possible to say that a particular rose is definitive of a particular region and/or period. But we can generalise about common characteristics: shape, strokes, colour, shading, degree of realism and detail.

ALSACE RUSTIC

- From 17th century onwards. Used mainly on wood.

- German influence.

- Simple, stylised and very naive. Swirled circular strokes.

- Usually medium red.

- Simple dark green oval leaves — no detailing.

- Composition is rigidly symmetrical.

DORDOGNE AND PERIGORD

- 18th and 19th centuries. Used on faience.

- Italian and Spanish influences.

- Very stylised. Large, circular bowl, divided by an S. Smaller inner bowl. Throat is a perfect circle.

- Outer petals are formed by one row of commas which start at the base of the S, that is, the centre bottom of the bowl. The outer petals are arranged right around the bowl, except for the very top.

- Shades of pink and burgundy. Colours reminiscent of Strasbourg and Savoie roses.

- Simple teal green comma stroke leaves, some with a fine, curved line continuing from the top of the comma.

- Usually paired with pinwheel daisies. Balanced design, but not necessarily symmetrical.

ILE-DE-FRANCE AND LOIRE VALLEY

- 18th and 19th centuries. Used on wood, for example, *armoires* and clocks.

- Dry brush roses, very casually applied. Strokes sometimes scratchy.

- Shape of rose is impressionistic, not rigidly defined.

- Colours: earth tones.

- Asymmetrical, relaxed compositions.

LIMOGES

- From late 18th century. Used on porcelain.
- Produced in the Limoges region, site of France's first discovery of kaolin, the precious white clay used to make hard-paste porcelain (1769).
- Very naturalistic and detailed, reminiscent of the Sèvres rose.
- Compact, rounded shape with deeply shaded throat.
- Bowl is sharply highlighted and almost always split. Top of bowl has a scalloped edge.
- Sophisticated shading, rendered by fine artists.
- Range of pinks and reds.
- Asymmetrical, flowing compositions.
- In a Limoges bouquet the rose is always the focus.

MONTPELLIER

- From 17th century to the present day. Used mainly on faience.
- Simple strokework rose. Single bowl, divided in two by an S-stroke, with commas of graduated size on either side. Two larger side petals and five or six bottom petals.
- Cobalt blue with white overstrokes, on a sunny yellow background.
- Olive green, oval leaves. Sometimes veins are outlined.
- Composition is often symmetrical.

SAVOIE

- 18th century. Used on faience.
- Strasbourg, Italian and Swiss influences.
- Very pretty. A more casual, simplified version of the Strasbourg rose. Impressionistic in style.
- Usually dark plum pink.
- Single bowl, sometimes split. Casually stroked petals, applied in swirls.
- Teal green oval leaves.
- Asymmetrical composition.

Roses

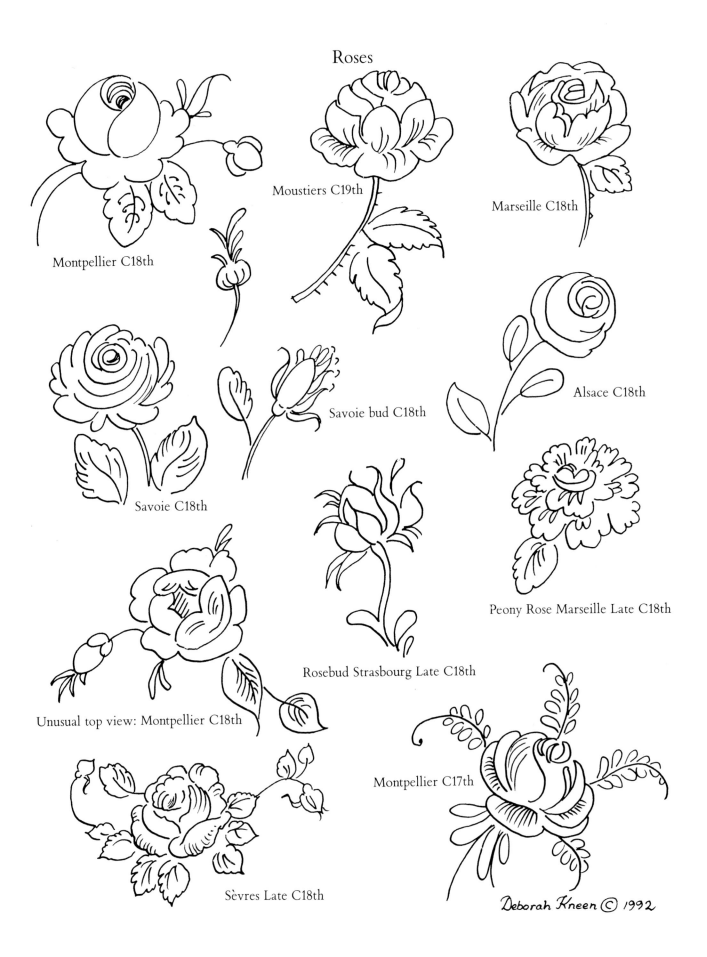

Montpellier C18th

Moustiers C19th

Marseille C18th

Savoie bud C18th

Alsace C18th

Savoie C18th

Peony Rose Marseille Late C18th

Rosebud Strasbourg Late C18th

Unusual top view: Montpellier C18th

Montpellier C17th

Sèvres Late C18th

Deborah Kneen © 1992

Roses

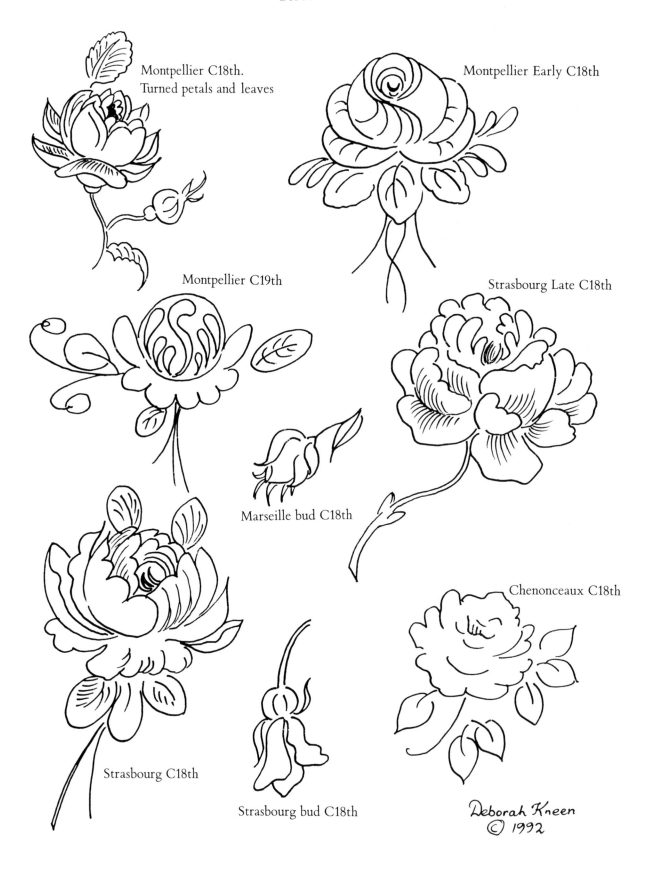

Montpellier C18th.
Turned petals and leaves

Montpellier Early C18th

Montpellier C19th

Strasbourg Late C18th

Marseille bud C18th

Chenonceaux C18th

Strasbourg C18th

Strasbourg bud C18th

Deborah Kneen
© 1992

SEVRES

- From mid to late 18th century. Used on porcelain, wood, fabric, tinware and plaster.
- Composition is loose and asymmetrical, a characteristic of the rococo period.
- Compact rounded shape with strongly shaded throat.
- Realistic with double or triple bowl, often split. Turned and twisted petals. Curved edges.
- Very detailed. Buds have calyx and sepals.
- Range of pretty pinks, including the Pompadour pink of the mid 18th century. Subtle shading.
- Leaves also realistic. Shaded and veined. Serrated edges. Some leaves in profile. Range of leaf sizes.
- In a Sèvres bouquet, the rose is always the focal point.
- Very influential. This rose has been used widely ever since — on furniture, ceramics, fabrics, wallpaper, carpets.
- Sèvres roses of early to mid 19th century become even more detailed and realistic with multiple bowls and complex shading.

STRASBOURG

- Late 18th century. Used on faience and porcelain.
- Oriental and German (Meissen) influences.
- Known as *roses au naturel* or *roses fines*.
- Casual, naturalistic roses, usually plum pink. Many full blown roses. Scalloped and frilly edges to some petals.
- Colour applied semi-transparently. Shading created with deeper application of colour or by hatched lines.
- Very detailed. Double or triple bowl, often split. Detailed throat.
- Outlined (*chatironné*), usually in plum purple.
- Oval, teal green leaves with veins and hatched shading. Serrated or scalloped edges.

Tulips

Here tulips bloom as they are told.

Rupert Brooke (1887–1915)

Tulips came originally from China and were an expensive rarity in 17th century Europe. Imported into Amsterdam by the Dutch East India Company, these flowers possessed an almost mystical quality. European folk artists took them particularly to heart, using the tulip with its three points as a symbol for the Holy Trinity.

This simple, three-pointed motif appears in faience ware from Rouen, on the painted wood of Alsace and in 17th and 18th century rustic ceramic designs from the south.

In Strasbourg, from the mid 18th century, tulips were not used for their symbolic value but rather for their elegant aesthetic appeal alone.

Strasbourg tulips are lush and frilly, their petals scalloped and veined with hatched lines and shaded colour. Like all the *fleurs au naturel*, they are not stiff and formal but loosely bunched, as if they have just been picked from the garden. Some petals are drooping and some upright. The flower is asymmetrical. Leaves are ribbon-like and flowing. They are turned and twisted several times.

By contrast to the *décor folklorique* tulips, the Sèvres and Limoges varieties were based on botanical engravings and painted by fine rather than folk artists. Hence, they display great detail and beautiful gradations of colour.

Tulips

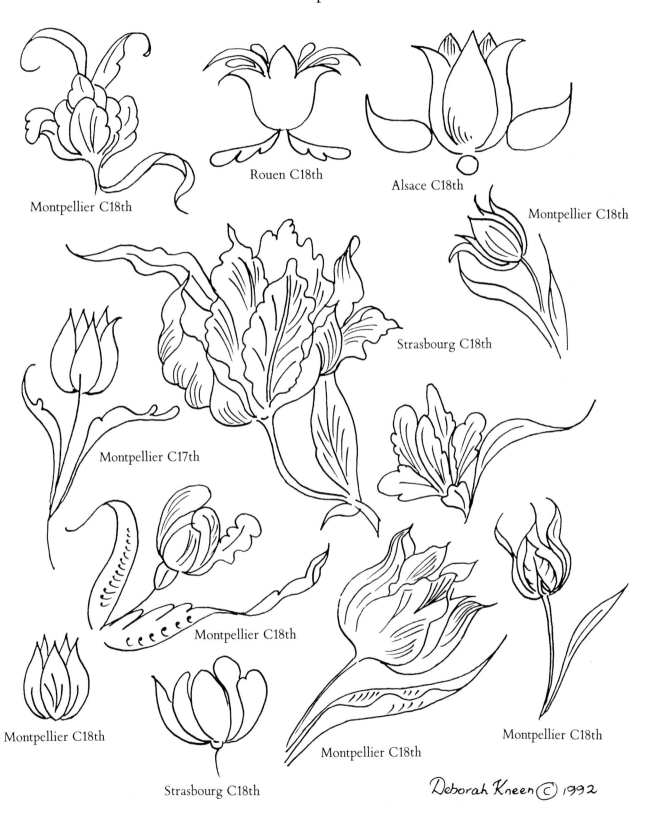

Montpellier C18th

Rouen C18th

Alsace C18th

Montpellier C18th

Strasbourg C18th

Montpellier C17th

Montpellier C18th

Montpellier C18th

Montpellier C18th

Montpellier C18th

Strasbourg C18th

Deborah Kneen © 1992

Carnations

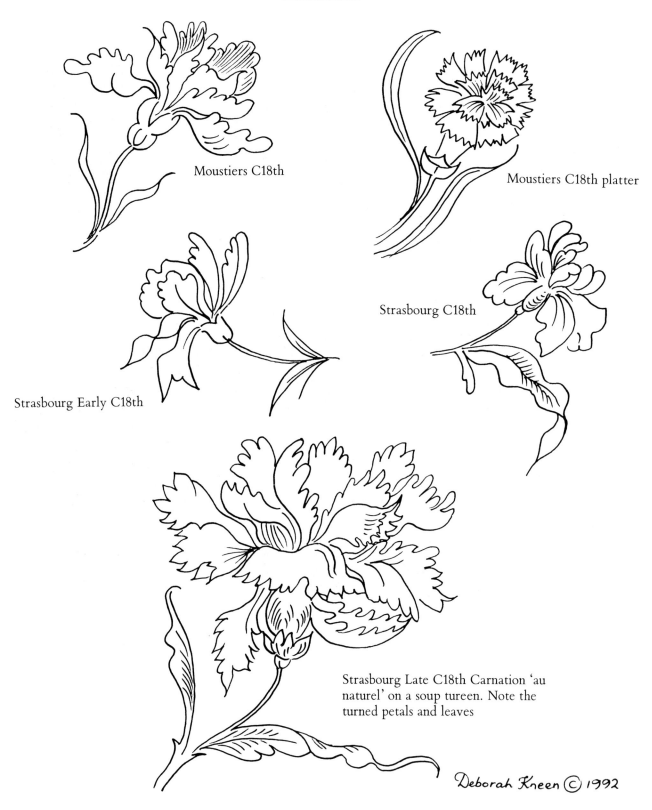

Moustiers C18th

Moustiers C18th platter

Strasbourg C18th

Strasbourg Early C18th

Strasbourg Late C18th Carnation 'au naturel' on a soup tureen. Note the turned petals and leaves

Deborah Kneen © 1992

Violets, Pansies and Bulbs

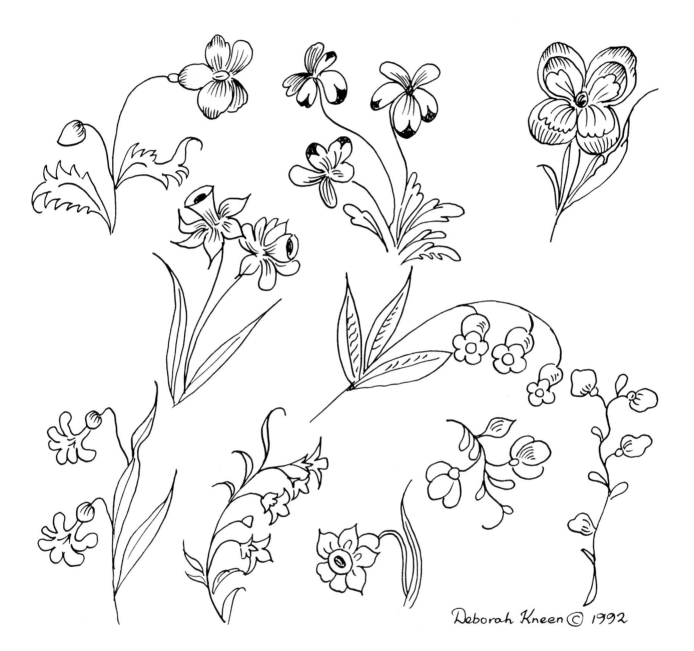

Deborah Kneen © 1992

Anemones, Poppies, Daisies and Other Flowers

Deborah Kneen
© 1992

Roses

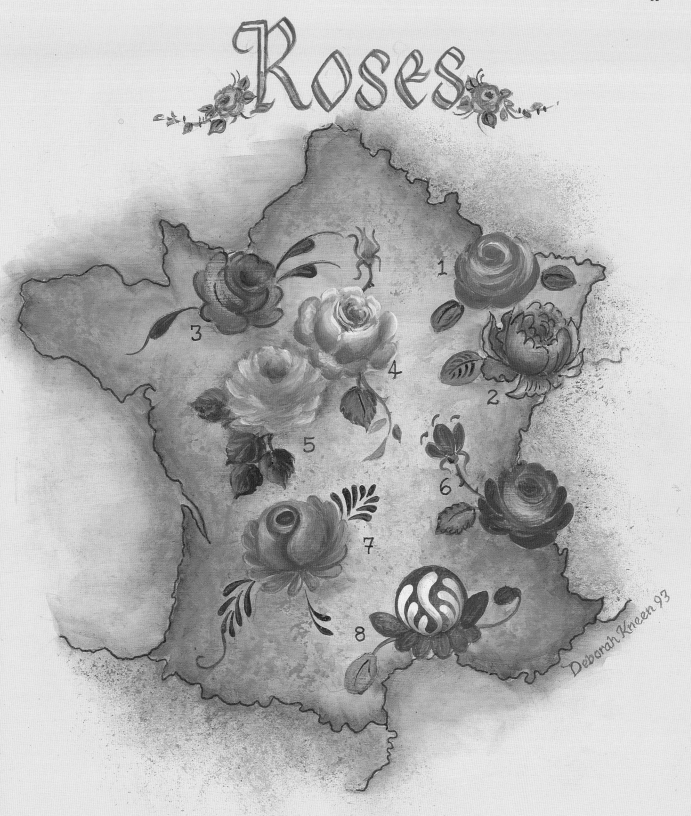

Roses of France: the map

1. Alsace rustic **2.** Strasbourg 'au naturel'

3. Rouen **4.** Old Sèvres **5.** Loire Valley dry brush

6. Savoie **7.** Dordogne/Périgord **8.** Montpellier

Regional roses, step-by-step

Montpellier

 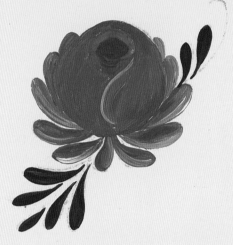 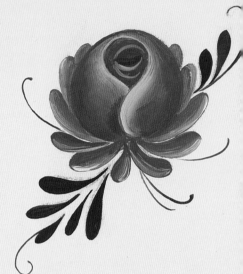

Dordogne

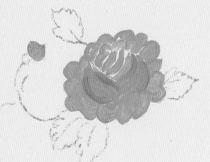 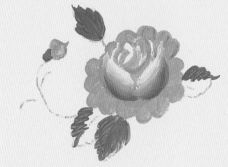 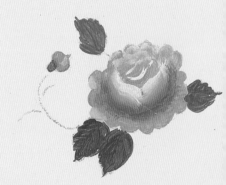

Old Sèvres

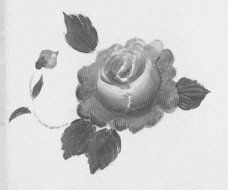 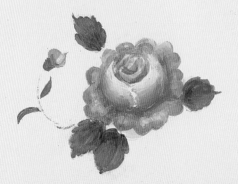 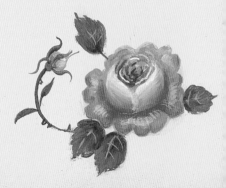

Rose

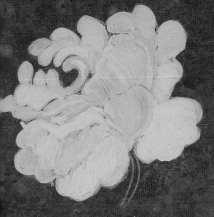 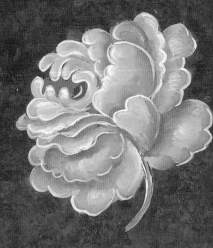

Forget-me-nots

Carnation

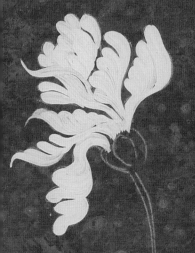 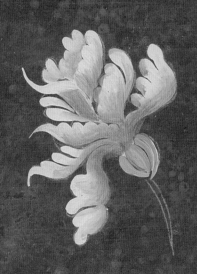 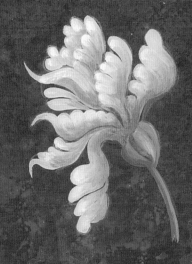

Tulip

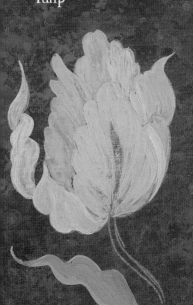 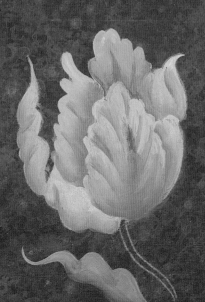 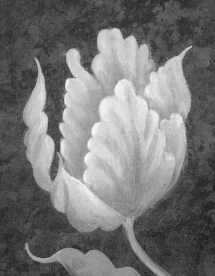

Deborah Kneen 93

Cherubs, step-by-step

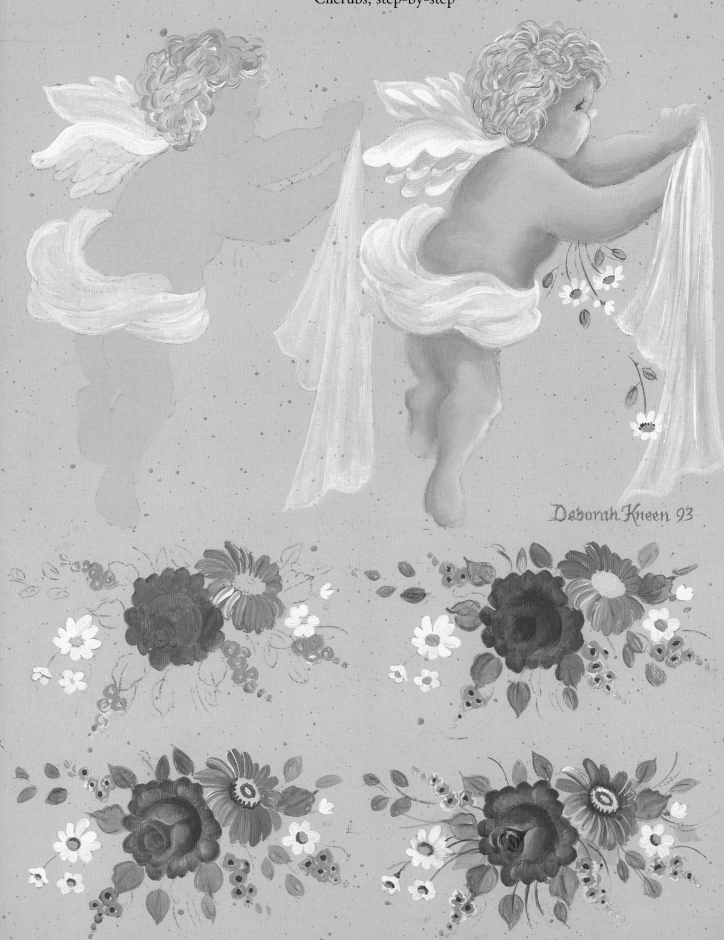

Deborah Kneen 93

Giverny flowers, step-by-step

Daffodils

Purple veronica

Deborah Kneen '93

Scenes, step-by-step

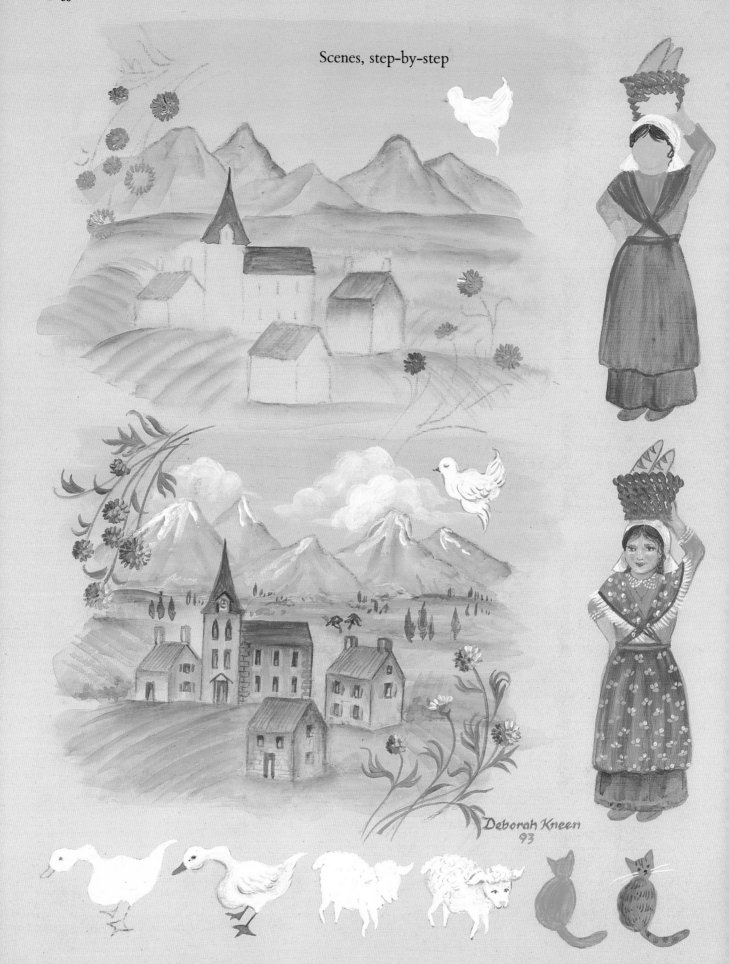

Deborah Kneen
93

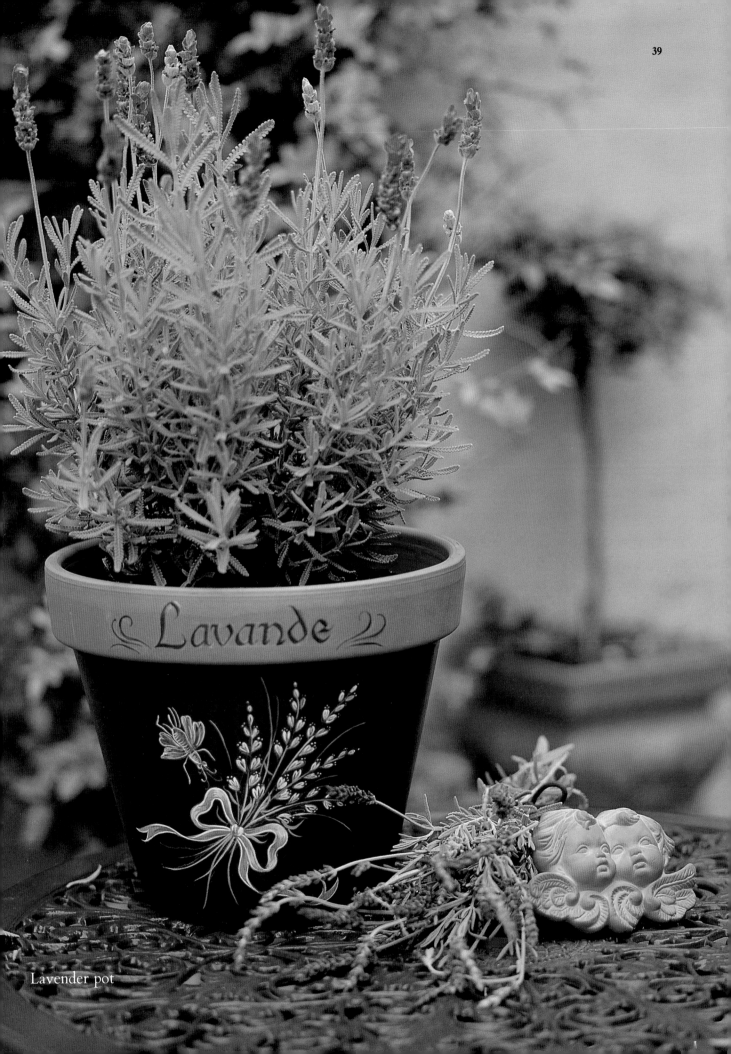

Lavender pot

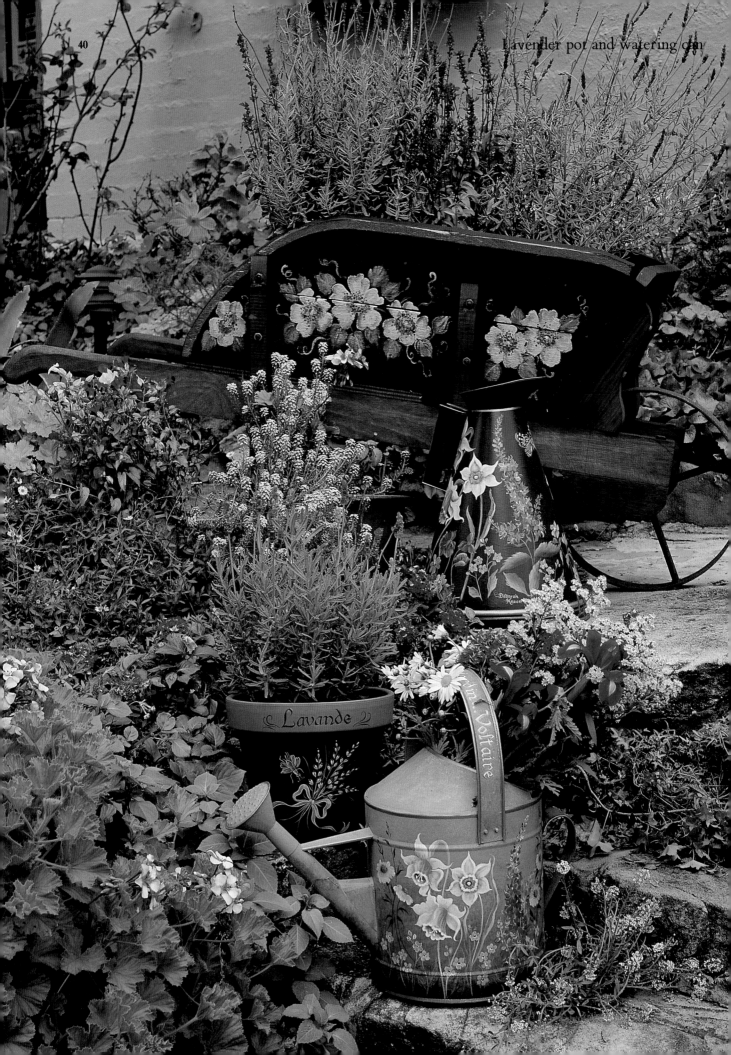

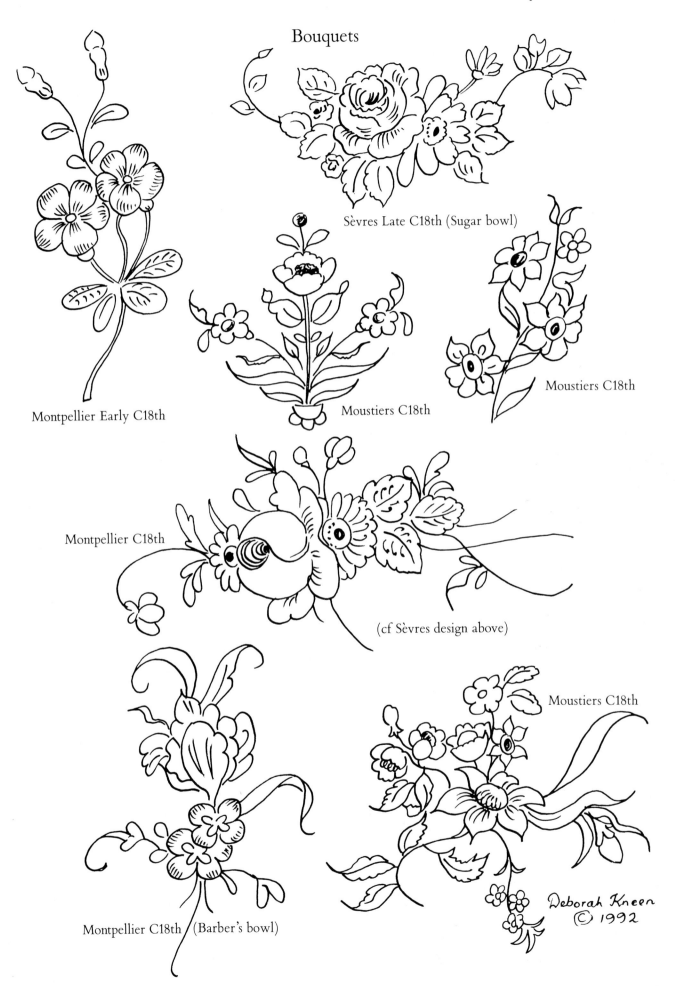

Bouquets

Sèvres Late C18th (Sugar bowl)

Montpellier Early C18th

Moustiers C18th

Moustiers C18th

Montpellier C18th

(cf Sèvres design above)

Moustiers C18th

Montpellier C18th / (Barber's bowl)

Deborah Kneen
© 1992

Filler Flowers

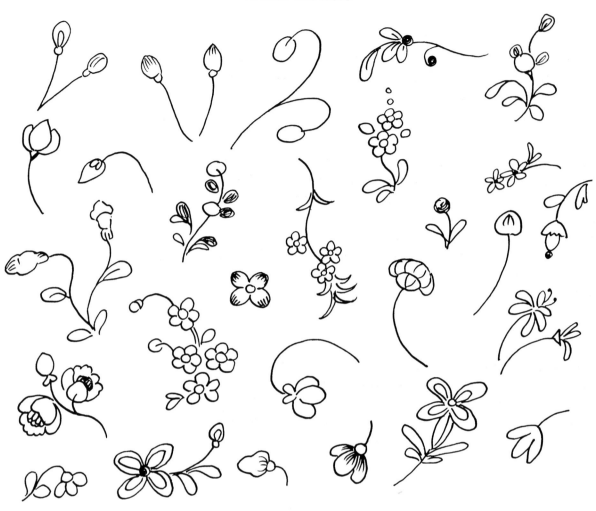

Insects

Deborah Kneen © 1992

LEAVES

Men in their generations are like the leaves of the trees. The wind blows and one year's leaves are scattered on the ground; but the trees burst into bud and put on fresh leaves when the spring comes round.

Homer, *The Iliad* (c. 900 B.C.)

It is fascinating to examine leaves as a study in themselves. Folk art leaves often bear little resemblance to the true botanical form. Early designs feature very stylised, non realistic leaves.

Colour realism is thrown to the wind. On a late 16th century faience platter from Moustiers, for instance, rose leaves are painted orange, dark blue and green. An 18th century daisy on a tile from Montpellier has leaves of aqua, yellow, olive green and dark blue. Otherwise, leaves are generally teal or olive green.

The comma is, without doubt, the most popular leaf motif. It accompanies any number of different flowers. Sometimes stems hold a series of commas, graduated in size or perhaps configurations of two or three commas. The leaves of the Dordogne/Périgord rose are perfect examples of this.

In 17th and 18th century faience landscapes, trees and bushes are charmingly depicted with comma stroke branches and leaves. The tree trunks are unnaturally elongated with foliage at the very top, a characteristic common to many European folk art forms and seen across the Atlantic in the mural paintings of American itinerant folk artist, Rufus Porter.

In the mid to late 18th century more realistic leaves begin to appear in *décor folklorique*. With the trend towards naturalism, leaves become more detailed, with veining and hatched shading. Turned leaves appear for the first time. Edges are serrated. The impact of rococo style is evident in the flowing asymmetrical leaves of the *bouquets au naturel* from Strasbourg.

In the 18th century, small bunches of leaves known as *petits motifs aux feuilles* are also scattered here and there around the main design. These tiny leaf configurations are usually arrangements of dots, crescents and commas.

Leaves

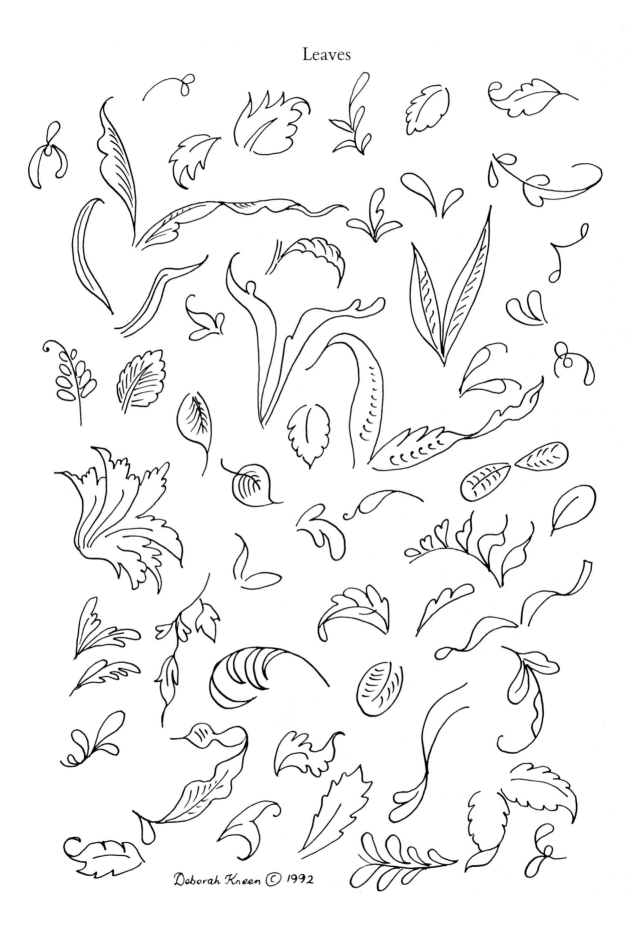

Deborah Kneen © 1992

PROJECTS TO PAINT

In this collection you will find projects to suit all levels of painting ability. The joy of *décor folklorique* is that it is within the reach of even those who do not have so-called natural artistic talent. Whereas some other forms of decorative painting are virtually fine art in disguise, many of these rustic designs are simple and easily mastered.

The projects are organised according to level of difficulty, beginning with a lavender pot which is within the capabilities of even the most inexperienced painter. The majority of projects are aimed at intermediate level painters. The clock, watering can and triptych, however, are intended for experienced folk artists.

A Colour Conversion Chart on page 132 will help you to convert colours to different paint brands. Remember that the matches will not be exact equivalents but are close enough to achieve the desired effect. All these brands can be inter-mixed.

A suggested list of brushes is supplied for each project, but this is a guide only. Choice of brushes is very much a personal matter. Some people never use a liner brush and paint all line work with an all-purpose round brush. Others do not use flats at all but side load a round brush. Decide what is best and most comfortable for you. But do try to keep an open mind about new brush techniques.

As a long-time round brush devotee, I have also come to appreciate and utilise the versatility and convenience of flat brushes. In these projects, I've taken some 'short-cuts' with techniques. Traditionally colour was blended with a round brush to create highlights and shadows. Today, we have flat brush methods such as floating and side-loading, developed in the US, which take the time and effort out of blending. Some of the flowers in this book, such as the Old Sèvres roses, are blended with both round and flat brush techniques. Developing a wide variety of brush skills will give depth and interest to your work.

I have also found that fingertips are great for blending, particularly smudging harsh edges. Likewise, when a wash looks too heavy, blot it with your finger or, if you are not a 'hands-on' painter, use a cotton bud or small piece of cloth.

Be flexible in your approach to painting. Welcome and share new ideas. Glean tips and techniques from teachers, books and magazines. Experiment with new products.

We are very fortunate as modern folk artists to have an exciting array of excellent, non-toxic materials available to us. The folk artists of earlier centuries had to make their own paint and often used toxic pigments and glazes, many containing lead, which caused terrible health problems.

Today there is no reason why you, as a folk artist, should be exposed to toxic substances. The philosophy behind all my work is the use of safe products. Oil-based antiquing, for example, produces toxic fumes in both the application and clean-up. Do you really want to expose yourself to these dangers?

Only water-based, non-toxic paints, varnishes and antiquing mixtures appear in this book. You will find that painting, antiquing and varnishing the non-toxic way is as effective as using oil-based materials. And it is a great deal quicker and cleaner!

So let's get to work, and *bonne chance!*

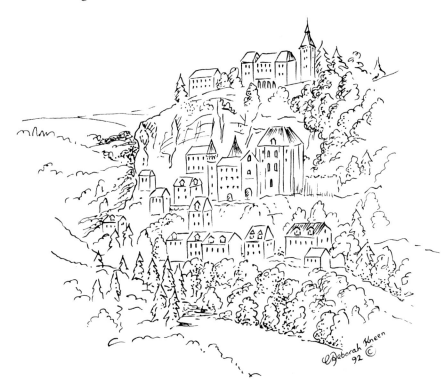

Mediaeval *village perché* of Rocamadour

LAVENDER POT

Here's flowers for you:
Hot lavender, mints, savory, marjoram.

William Shakespeare (1564-1616), *A Winter's Tale*

The south of France evokes images of olive groves, sun-drenched hills and, of course, fields of lavender. Over 8 000 hectares of lavender are cultivated in Provence. At Grasse on the Côte d'Azur, lavender essence is used to make perfume. Roadside stalls sell lavender honey and dried lavender flowers in sachets of pretty floral fabric. In the restaurants of Provence the visitor can sample lavender bread and even lavender ice cream!

This beginners' project, featuring a simple bouquet of lavender, uses a limited palette and can be completed in a couple of hours. To protect your pot, do not plant directly into it. Instead, place a plastic pot inside.

MATERIALS

Paints
Warm White, Dioxazine Purple, Pine Green, Rose Pink, Rich Gold.

Brushes
No. 2 round brush. No. 00 liner brush.

PREPARATION

Hose the pot to remove dust. Allow to dry. Base coat with a proprietary base colour. These products are a special mixture of paint and gesso, or varnish, which seals off the porous terracotta surface.

I used Plaid FolkArt Base Coat in Bottle Green and left the rim of the pot unpainted.

TRANSFERRING THE PATTERN

Transfer the pattern with white transfer paper or sketch on the design with a chalk pencil.

DECORATING

LAVENDER

Using the No. 2 round brush, brush mix Warm White and a small amount of Dioxazine Purple. Paint the lavender flowers, stroke by stroke.

LAVENDER STEMS

Use the liner brush to paint the stems Pine Green plus Warm White. Remember to dilute the paint with water to make it flow well.

INSECT

With the round brush, paint the insect in watery Warm White. Add some watery Dioxazine Purple to the wings. When dry, outline with undiluted Warm White, using the No. 00 liner brush.

BOW

Using the No. 2 round brush, double load Rose Pink and Warm White to paint the bow. Make flowing strokes. Highlight the wide parts of the ribbon with Warm White.

LETTERING

With a liner brush, carefully paint the lettering (*lavande* meaning lavender) in Bottle Green. Shadow outline with Rich Gold. Have a damp cotton bud handy to remove any mistakes.

FINISHING

Finish with water-based satin varnish.

CARING FOR YOUR LAVENDER

Place in a sunny position. Water frequently but ensure the soil is well drained. Prune lightly at the end of summer to prevent the lavender becoming untidy.

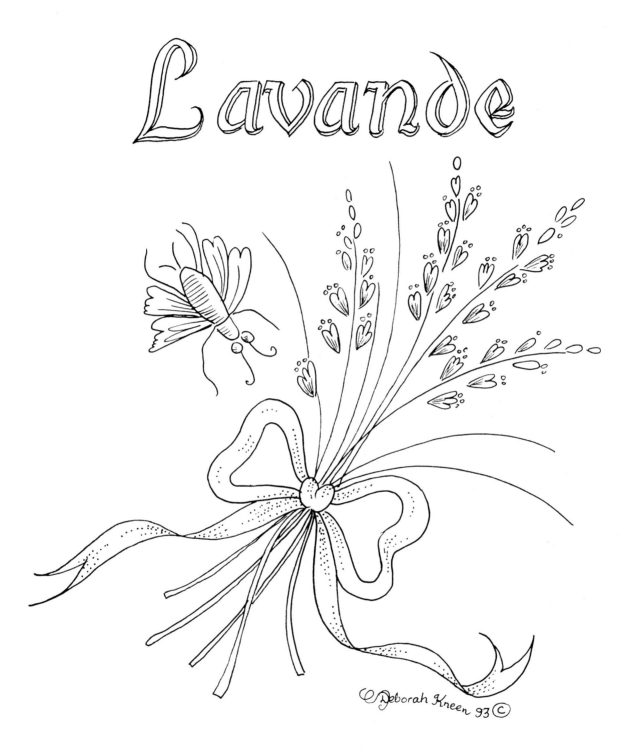

Deborah Kneen 93 ©

PEPPER MILL
WITH MONTPELLIER ROSE

Though the mills of God grind slowly, yet they grind exceeding small;
Though with patience He stands waiting, with exactness grinds He all.

H. W. Longfellow (1807–1882)

One of the first spices to be introduced into Europe, pepper was used by Hippocrates in his prescriptions. Ground pepper rapidly loses its flavour and aroma, so peppercorns are best stored in a pepper mill (*moulin à poivre*) and ground as required.

Our peppermill is decorated with a traditional design and colour scheme: a dark blue Montpellier rose and white pinwheel daisies on a sunny yellow background.

Montpellier is an old university city with a small mediaeval town centre of rambling cobbled streets filled with cafés and restaurants. The town centre is bordered by impressive 19th century boulevards, squares and a triumphal arch, reminiscent of Paris.

MATERIALS
Paints
Ultramarine, Warm White, Carbon Black, Yellow Oxide, Brown Earth, Norwegian Orange, Pine Green.

Brushes
Base-coating brush, No. 2 round brush, No. 00 liner brush, No. 10 or 12 flat brush.

PREPARATION
Sand the pepper mill lightly. Wipe clean. Base coat with two or three smooth coats of Yellow Oxide.

TRANSFERRING THE PATTERN

When the base coat is completely dry, sketch on the rough outlines of the design or transfer with grey graphite transfer paper.

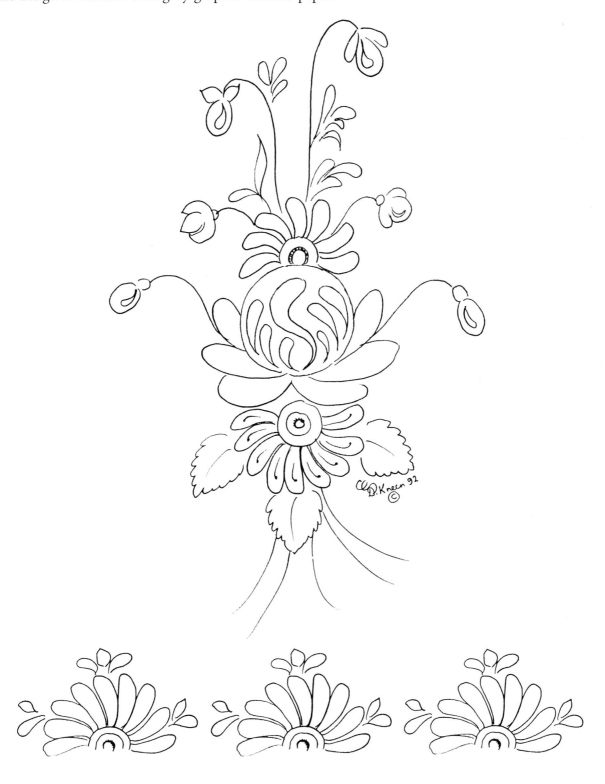

DECORATING

GENERAL TIPS
For this traditional project, load your brush generously with paint and reload for each stroke. Ensure that paint consistency is rich and creamy. Dried up paint will not produce good strokes.

BLUE ROSE
Refer to the step-by-step guide on page 34. Base paint the rose Ultramarine. Allow to dry. Mix Ultramarine with Carbon Black and side-load the flat brush. Shade the bowl as shown on page 34. Sketch on the S and comma strokes with a white chalk pencil and paint them Warm White.

PINWHEEL DAISIES
Using the round brush, paint the petals Warm White. The daisy above the rose has teardrop stroke petals. The other daisies have comma stroke petals. Let the petals dry, then apply a second coat.

Paint the centres Yellow Oxide plus Warm White. Let dry. Paint circles of Brown Earth and Norwegian Orange in the centre.

LEAVES
Large leaves are painted with slightly watery Pine Green plus Yellow Oxide to make a medium olive green. When dry, load a liner brush with Pine Green plus Carbon Black and paint the central veins. Outline the scalloped edges of the leaves, but be casual about this. Do not outline every single edge.

Small leaves are comma strokes of Pine Green plus Yellow Oxide.

BUDS
Base the buds in Norwegian Orange or Ultramarine. When dry, paint a Warm White comma stroke on each bud.

STEMS
Stems are painted Pine Green plus Carbon Black with a liner (or preferably a script liner) brush. The paint should be watered down so that it will flow well.

FLOATED SHADING
Wet the flat brush and side load into Brown Earth. Blend well on your palette. Now lightly float the Brown Earth on the base of the rose bowl, around the base of the daisy petals and around some of the outside edges of the flowers and leaves to create soft shadows. This is a form of selective antiquing.

BANDING

Carefully paint the bands Ultramarine or Norwegian Orange with the No. 2 round brush.

FINISHING

Decide whether you want a matte or gloss finish. The gloss will simulate glazed porcelain, while the matte finish will retain the look of wood. Apply three or four coats of water-based varnish in the finish of your choice.

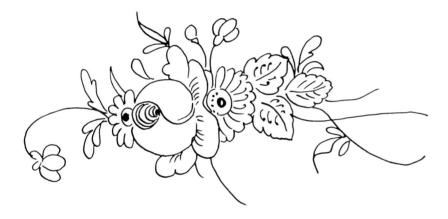

FRENCH VILLAGE

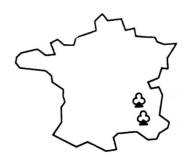

A l'heure où la rosée au soleil s'évapore
Tous ces volets fermés s'ouvraient à sa chaleur,
Pour y laisser entrer, avec la tiède aurore,
Les nocturnes parfums de nos vignes en fleur.

Alphonse de la Lamartine (1790–1869)

(When the dew evaporates in the sun, all the window shutters are opened to the sun's warmth, to let in the mild dawn and the lingering perfumes of the vines in flower.)

This little village is typical of hundreds scattered across the country. France remains largely a rural economy, and, in many of the more remote villages, particularly in the Hautes Alpes and the Midi, life goes on much as it has for centuries.

The main square of a typical French village contains the *mairie* (town hall) with its *tricolore* proudly flying, the *café*, hub of village social life, the *boulangerie-pâtisserie* (bakery/cake shop) and, of course, the *église* (church).

I based this village on real buildings from towns along the scenic Route Napoléon, stretching from Grenoble to Cannes. The *boulangerie*, is from St Bonnet in the Champsaur valley, the church from Castellane on the Verdon River in Provence.

An ideal intermediate-level project, the buildings are first pickled with a pastel stain, then the main details are inked in and coloured with washes. No liner work with the brush is required.

MATERIALS
Paints
Rose Pink, Smoked Pearl, Nimbus Grey, Carbon Black, Gold Oxide, Aqua, Titanium White, Pine Green, Yellow Oxide, Ultramarine, Napthol Red (see Chart, page 132), Brown Earth.

Brushes
Large flat brush for pickling. No. 1 or 2 round brush. No. 6 flat brush.

Extras
Pencil or grey graphite transfer paper. Waterproof permanent fine point black ink pen. (Check on a sample board that the ink will not run when water or varnish is applied over it.) Ruler. Retarder.

PREPARATION AND PICKLING

Sand the buildings well and wipe clean. Do not seal. An old 12.5 mm (½ inch) flat brush is ideal for applying the pickling stain to the buildings. Make two pickling mixtures: Rose Pink and retarder, and Smoked Pearl and retarder. The pickling mixtures should be runny in consistency and semi-transparent when applied to the wood, allowing the grain to show through. Apply quickly to the walls. Have an old cloth handy to wipe off any excess. Repeat if a deeper colour is desired.

Pickle the roof areas with either Nimbus Grey plus a touch Carbon Black and retarder, or Gold Oxide and retarder.

Allow the pickling to dry well, preferably overnight.

TRANSFERRING AND INKING THE DESIGN

Lightly sketch or transfer the design. Repeat the various motifs for the sides and backs of the buildings. Carefully ink the details using a permanent ink pen with a fine point. Use a ruler, if necessary. Take care when inking — mistakes cannot be erased.

COLOUR WASHES

Shutters, doors, windows and so forth are painted using washes of colour. A wash is a semi-transparent application of watery paint. You will need to judge the right consistency for yourself — too dry and the colour will be opaque; too much water and the wash will run out of control. The colour washes can be applied with a No. 1 or 2 round brush.

SHUTTERS
Aqua.

DOORS
Gold Oxide.

WINDOW PANES
Titanium White.

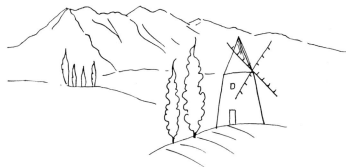

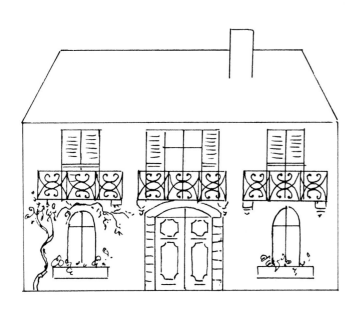

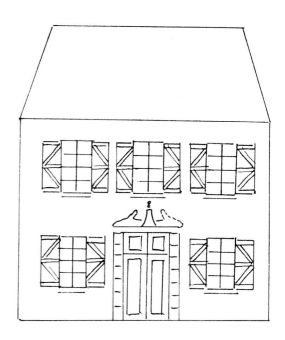

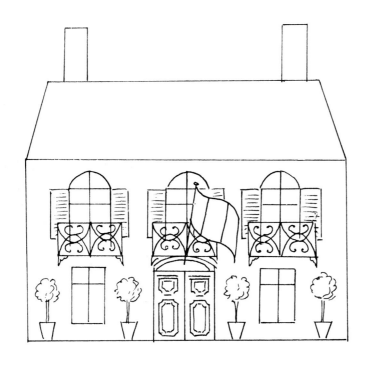

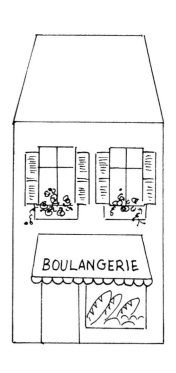

FLAG
Stripes are Ultramarine, Titanium White and Napthol Red.

FOLIAGE
Pine Green plus touch of Yellow Oxide. Shade with Pine Green plus touch Carbon Black.

GERANIUMS
Napthol Red plus touch Yellow Oxide.

Note: You may prefer to paint the washes first, then ink in the lines. If so, this will be equally effective. Ensure, however, that the washes are thoroughly dry before inking or the ink will run!

FLOATED SHADING
Using a No. 6 flat brush, softly float Brown Earth around the edges of the buildings. Float in some shadows around and under the windows and doors. Float Carbon Black lightly along the edges of the grey roofs and Brown Earth along the edges of the Gold Oxide roofs.

To keep the floated colour soft, you may wish to pre-wet the edge areas with water before floating.

FINISHING
When the buildings are thoroughly dry, varnish with two coats of water-based matte or satin varnish, and enjoy your French village.

OLD METALWARE
WITH DORDOGNE FLOWERS

Vivez, si m'en croyez, n'attendez à demain:
Cueillez dès aujourd'hui les roses de la vie.

Pierre de Ronsard (1524–1585)

(Live, take my advice, don't wait until tomorrow: Pick the roses of life today.)

Bright roses and pinwheel daisies from the Dordogne/Périgord region decorate these tôle pieces. The designs are adapted from an early 19th century vase, tureen and plates I discovered in the mediaeval clifftop *village perché* of Rocamadour, a popular destination for pilgrims in the Middle Ages.

MATERIALS
Paints
Warm White, Rose Pink, Burgundy Red (see Chart, page 132), Brown Earth, Napthol Red (see Chart, page 132), Yellow Light, Norwegian Orange, Dioxazine Purple, French Blue, Ultramarine, Brown Earth, Teal Green.

Brushes:
No. 2 or 3 round brush. No. 00 liner brush. No. 6 or 8 flat brush.

PREPARATION

Prepare old metal by scouring off excess rust, painting with rust-preventative metal primer and base coating in artists' acrylics in an appropriate background colour.

For new metal, wash with a solution of equal parts water and white vinegar to remove the oil coating which manufacturers customarily apply to protect the surface. Dry thoroughly. It is important that no moisture is trapped in crevices. Then seal with

a metal primer such as Penetrol. Lastly, paint the metal in the acrylic base colour of your choice.

TRANSFERRING THE PATTERN

Transfer the patterns with white transfer paper or roughly sketch the design with a chalk pencil.

DECORATING

Unless otherwise stated, all steps use the No. 2 or 3 round brush.

DORDOGNE ROSE

Refer to the step-by-step guide on page 34.

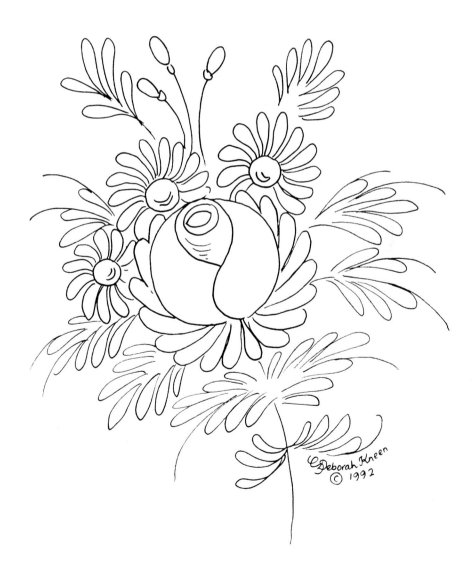

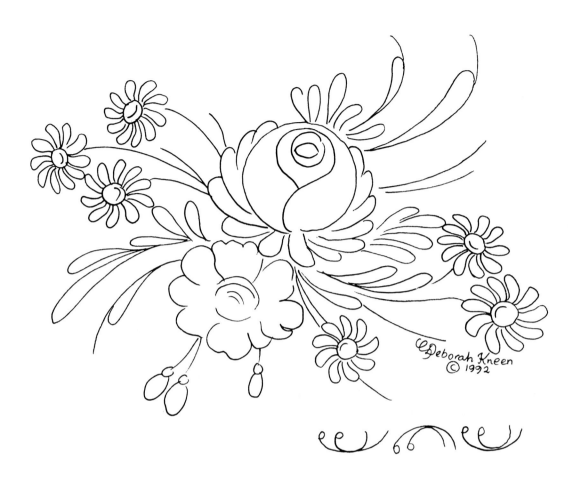

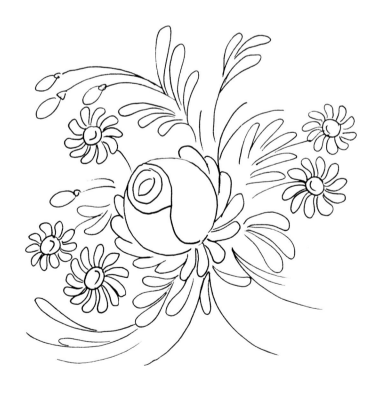

LARGE BOWL

Paint the two halves of the large bowl separately. Base the bowl in Warm White plus Rose Pink. Let dry. With the flat brush, float Burgundy Red on the left side of the S which divides the bowl. Float the same colour at the base of the bowl and on the far left edge of the bowl. Highlight the right side of the bowl with a soft float of Warm White.

SMALL INNER BOWL

For the small inner bowl, shade the bottom area with Burgundy Red and highlight the top with Warm White. The circular edge of the small inner bowl is Warm White.

THROAT

For the throat, shade the top with Burgundy Red plus a touch of Brown Earth.

OUTER PETALS

Paint the comma stroke outer petals in a darker version of the base colour, that is, more Rose Pink and less Warm White. Allow to dry.

Paint a thin wash of Napthol Red over the entire rose, blotting with a cloth if the wash is too heavy.

PINWHEEL DAISIES

Pinwheel daisies are composed of comma strokes. You should ensure the paint is fresh and creamy. Reload for each stroke. The daisies are painted:

1. Warm White plus Yellow Light and a touch of Norwegian Orange.
2. Warm White plus small amounts of Dioxazine Purple and French Blue.
3. Warm White plus Ultramarine.

The centres are Yellow Light plus Warm White. When dry, use the liner brush to paint the semi-circular lines in Brown Earth.

COMMA LEAVES

Paint the comma stroke leaves Teal Green plus a touch of Cream (Warm White plus a small amount of any yellow). With a liner brush paint the fine lines which flow from the fat part of the comma.

FLOATED SHADING

With a wet flat brush, lightly float Brown Earth around the base of the daisy petals. You can also float some shading at the base of the rose petals.

Assess your painting. Add more floats as required. Are the flowers bright enough against the background? If they are a little lost, repaint, adding extra Warm White to the various colours.

FINISHING

Finish with two coats of water-based matte or satin varnish. If you plan to use a metal item as a vase, do not pour water directly into the metal container. Always place a small jar inside.

RICOLORE TRIVET

Vive la nation!

Cry of the Revolutionaries, 1789

**J'aurais des couleurs admirables,
Du bleu, du blanc, du vermillon.**

Jean-Baptiste de Grécourt (1683–1743)

(I would have wonderful colours: blue, white and vermilion red.)

After the French Revolution the folk artists of Alsace imparted a special patriotic touch to their otherwise Germanic designs. Backgrounds of *armoires*, trunks and buffets were painted in the stripes of the *tricolore*. (See also page 17).

Our little trivet borrows this technique. The stripes are distressed with sandpaper to make them look suitably old and faded. In the centre is a naive scene (based on an old engraving) of French soldiers marching to battle.

The soldiers might well have been singing the battle hymn of the French republic, the Marseillaise. It was composed in 1792 by Rouget de Lisle, an artillery officer from the garrison in Strasbourg, capital of Alsace.

MATERIALS

Paints
Cream (see Chart, page 132), Ultramarine, Warm White, Napthol Red (see Chart, page 132), Brown Earth, Titanium White, Pine Green, Yellow Oxide, Carbon Black, Gold Oxide, Flesh Colour (see Chart, page 132).

Brushes
Base-coating brush. No. 6 or 8 flat brush. No. 2 round brush. No. 00 liner brush.

Extras
Fine sandpaper for distressing.

PREPARATION
Sand well. Base coat with three coats of Cream.

TRANSFERRING THE PATTERN
Transfer the pattern very lightly with grey graphite paper.

TRICOLORE STRIPES
Paint the stripes with smooth washes of Ultramarine, Warm White and Napthol Red respectively. Keep the colour semi-transparent. Allow to dry.

 With a No. 6 or 8 flat brush, float Brown Earth around the edges of the stripes and around the central octagon.

DISTRESSING
Take a fine sheet of sandpaper and lightly sand the striped border to remove some of the top layer of colour. Wipe clean.

DECORATING
Use the round brush, unless stated otherwise.

SCENE

SKY
Mix Titanium White and a touch of Ultramarine and paint a thin wash on the sky area. When dry, side load the flat brush and paint Titanium White clouds.

LAND
Wash in the land with watery Pine Green plus Yellow Oxide. Let dry. Then take a liner brush and paint the grass with fine strokes of Pine Green plus Carbon Black.

ROAD, CHURCH AND CASTLE
Paint these areas with a wash of Gold Oxide. Allow to dry. Add liner work of Brown Earth. The church roof is a wash of Brown Earth plus a touch of Carbon Black.

TREES
Trees are based in with double-loaded Pine Green and Carbon Black. Working wet-in-wet, add some strokes of Yellow Oxide on the left side of each tree.

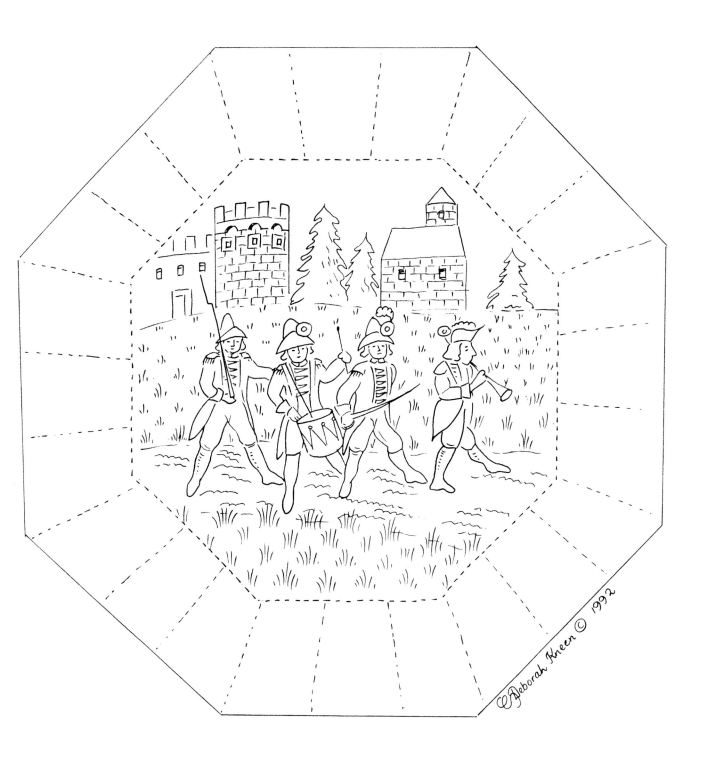

SOLDIERS

You will need to use a liner brush for the fine details. Keep the colours of the clothes watered down.

Faces and Hair: Flesh Colour for faces and hands. Let dry.

Features: Brown Earth, using a liner brush.

Hair: Brown Earth plus Carbon Black.

Hats: Brown Earth plus Gold Oxide.

Feathers: Titanium White.

Jackets: Ultramarine. Napthol Red detailing.

Shirts: Titanium White.

Collars: Napthol Red.

Trousers: Napthol Red.

Boots: Brown Earth plus Gold Oxide.

Drum: Gold Oxide.

Outline the figures in Brown Earth. Make these lines very fine.

FLOATED SHADING

With the flat brush, float Pine Green plus Carbon Black around the edges of the scene. Keep the float soft by pre-wetting the edges with water. An alternative is to apply one coat of water-based matte or satin varnish and then float.

FINISHING

If you intend to expose the trivet to heat, finish with four to six coats of water-based polyurethane varnish and allow the surface to harden for several weeks before use.

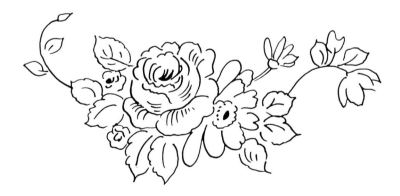

DAUPHINE COW BELL
WITH LANDSCAPE

Laisse-nous notre va-et-vient comme un troupeau dans ses sonnailles…

Jules Supervielle

(Allow us to wander about freely like a herd of cattle wearing its cow bells.)

The Dauphiné region of France stretches from the Alps in the north to Provence in the south. It is one of the most sparsely populated regions of France. The valleys of the French Alps are noted for their dairy farms which produce wonderful cheeses including the regional *tomme*, made from buttermilk.

Each morning, it is customary for the farmer to lead his cows out to graze on the rich pastures. The valleys are soon filled with the tinkling of cow bells.

In the Dauphiné, cow bells (*sonnailles*) can be purchased from village hardware stores (*quincailleries*) in an array of sizes and materials: copper, forged iron, steel and brass. The cow bell used for this project is from the tiny 16th century village of St Bonnet. The bell has a slightly rough texture, which adds character to the painted scene.

From spring to autumn the roads of the Hautes Alpes are lined with the mauve flowers of the globe thistle which serves as the border for our landscape.

MATERIALS

Paints
Aqua, Titanium White, Dioxazine Purple, Nimbus Grey, Red Earth, Pine Green, Yellow Oxide, Norwegian Orange, Carbon Black, Brown Earth, Warm White.

Brushes
No. 2 round brush. No. 6 flat brush.

PREPARATION

If the bell has a smooth finish, seal with one coat of Jo Sonja's All Purpose Sealer to give 'tooth' to the surface. Base coat if you wish. I did not seal or base coat my bell as the rough black *fer forgé* surface was ideal for painting.

TRANSFERRING THE PATTERN

It is best to paint the scene freehand, but if you do not have the confidence to do this, transfer only the essential details: mountains and house outlines. Use white transfer paper.

DECORATING

Adjust the colours according to the background colour. My bell has a black background so I needed to add white to the various colours so that they would show up. On a lighter background, you can work with a darker palette.

Refer to the step-by-step guide on page 38.

SKY AND CLOUDS

With the round brush, paint a very soft wash of Aqua across the sky area. Wet a No. 6 flat brush and side load it with Titanium White. With the colour facing towards the top of the bell, paint soft clouds.

ALPS

Use the No. 6 flat brush to block in the Alps with Light Purple (Titanium White plus Dioxazine Purple) and Nimbus Grey. Side-load both colours onto the one corner of the flat brush. Again, the colour should be facing upwards. Now float in the contours. When dry, repeat with Titanium White to create snow. Allow to dry and wash in some Red Earth at the base of the mountains.

LAND

Paint washes of Pine Green plus Yellow Oxide mixed with water to create hills, contours, etc. When dry, repeat with Red Earth.

FIELDS

The rows of crops are floated on with Yellow Oxide, using a side-loaded flat. Keep the colour watery. Float Red Earth rows between the Yellow Oxide.

BUILDINGS

With the No. 2 round brush, base paint the walls and chimneys Nimbus Grey. The church roof and steeple are Nimbus Grey plus Titanium White. The house roofs are Norwegian Orange plus a touch of Warm White. Using the flat brush, float Nimbus Grey shading on the church roof. Paint fine lines of Yellow Oxide on the orange roofs to suggest Roman tiles.

Windows and doors are painted Carbon Black with a liner brush. Leave a tiny gap unpainted in each door and window. Shutters are Aqua plus Titanium White and are outlined with Brown Earth.

Using the No. 6 flat, shade the edges and base of the buildings with Brown Earth.

Now assess your scene. Is there enough contrast? Do the mountains need highlighting with more snow? Do the clouds need to be painted a second time? Should the washes on the land be brighter? Repaint the areas you think need to be brighter, perhaps adding a touch of Warm White to the various colours.

Alternatively, if you feel the scene is *too* bright, it can be toned down by mixing Brown Earth and water to a very runny wash and applying it over the appropriate areas.

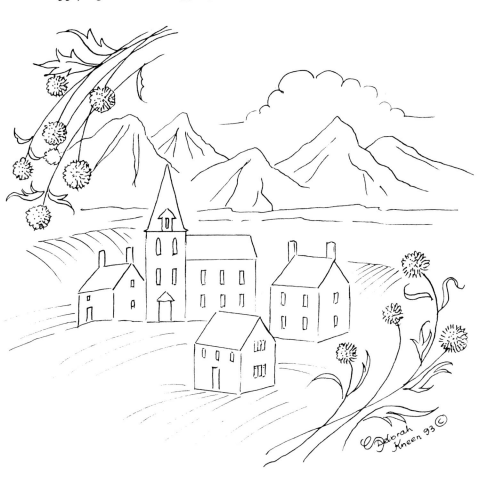

GLOBE THISTLE

Paint the thistle flowers with a mixture of Warm White and Dioxazine Purple. Whilst still wet, paint Titanium White on one side of each 'globe'. Make the edges of the globes fuzzy — no harsh lines. The sharply serrated leaves and stems are Nimbus Grey plus a touch of Warm White. Let the thistles dry and, if desired, tone with a wash of Brown Earth.

FINISHING

As the bell is a purely a decorative item, it need only be sealed with one or two coats of water-based matte or satin varnish.

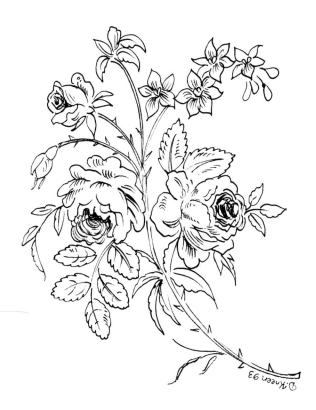

UTLERY BOX
WITH LOIRE VALLEY
DRY BRUSH FLORALS

It is a flower. If you pass your finger over it again and again, there is no longer any bloom, any charm, any coquetry.

Eugène Boudin (1824–1898), French painter

The cloud-capped towers, the gorgeous palaces…

William Shakespeare, *The Tempest*

If I had to select my favourite château of the many in the Loire Valley, I would not hesitate to choose the palace of Chenonceaux. It has drawn me back again and again, even in winter, and never ceases to enchant. Spanning the Cher River, the Renaissance château was home to a series of famous women, including Diane de Poitiers, mistress of Henri I. On Henri's death, Diane was expelled from the palace by the king's widow, Catherine de Medici. It was she who built the famous two-storey gallery over the Cher, inspired by the Ponte Vecchio in her native Florence.

Most of the painted decoration at the palace is *haut style*, but on the top floor of the gallery there is a lovely *armoire* painted with rustic, almost impressionistic garlands. I have used an adaptation of the design to decorate an equally rustic cutlery box. The autumn-toned flowers are composed of casual, dry brushstrokes which should not be overworked but painted in a relaxed manner. Bear in mind Boudin's thoughts as you paint.

MATERIALS
Paints
Rose Pink, Red Earth, Warm White, Napthol Red (see Chart, page 132), Brown Earth, Turner's Yellow, Norwegian Orange, Cream (see Chart, page 132), Pine Green, Carbon Black.

Brushes
Use the largest round brush you can handle, up to a size 4. The larger the brush, the more relaxed your strokes will be. You will also need a No. 10 or 12 flat brush for the floated shading.

PREPARATION

The cutlery box comes pre-stained and lightly waxed. Scuff up the area to be decorated by lightly sanding in the direction of the grain with a kitchen scourer.

TRANSFERRING THE PATTERN

Roughly sketch on the design in chalk pencil or transfer with white transfer paper.

DECORATING

ROSE

Brush mix Rose Pink, Red Earth and Warm White and stroke on the rose petals and bowl. Use lots of paint and don't be too precise. Paint in the throat with Napthol Red and Brown Earth. Stroke Rose Pink and Warm White over the top petals and on the right side of the bowl.

Paint a few tiny dots of Turner's Yellow in the throat. Let the rose dry.

Make a runny Red Earth wash and paint it over the entire rose. Blot with a cloth, if necessary.

OPEN YELLOW-ORANGE FLOWER

Brush mix Turner's Yellow and Norwegian Orange and paint the petals, working from the centre to the tip. Shade the centre with Brown Earth.

With Turner's Yellow and Norwegian Orange, paint the stamens in the centre.

SMALL YELLOW ROSE

Double load Warm White and a touch of Turner's Yellow and paint swirling circular strokes to suggest the petals. The throat is Brown Earth and Norwegian Orange. When dry, add some Turner's Yellow detailing on the throat, and stroke Warm White over some of the petals.

DAISIES

Paint the daisies with a dry brush and scratchy strokes of Cream. Overstroke with Warm White. Centres are Turner's Yellow, shaded at the base with Brown Earth and Norwegian Orange. Paint Warm White dots on the centres.

Paint watery Brown Earth lightly around the base of the petals. This can be done with a round brush or floated with a flat.

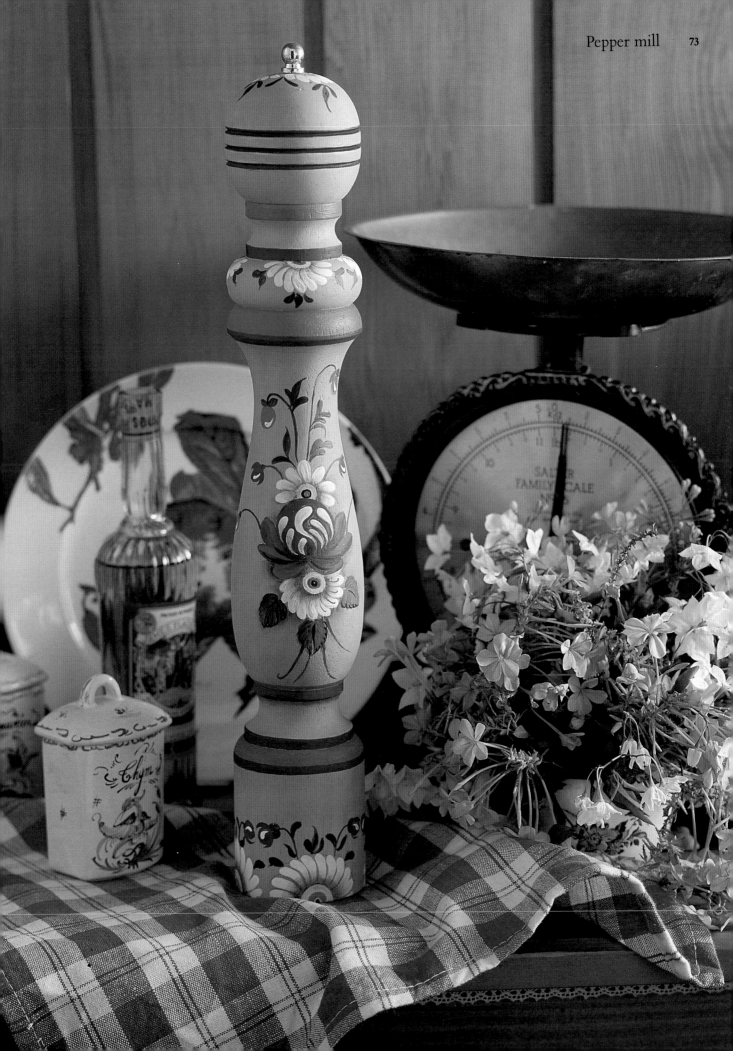

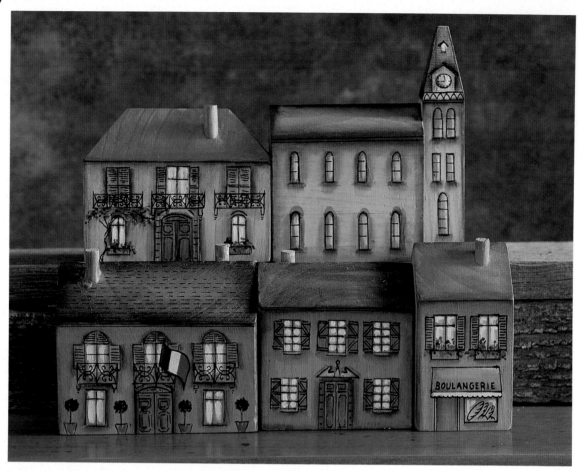

French village

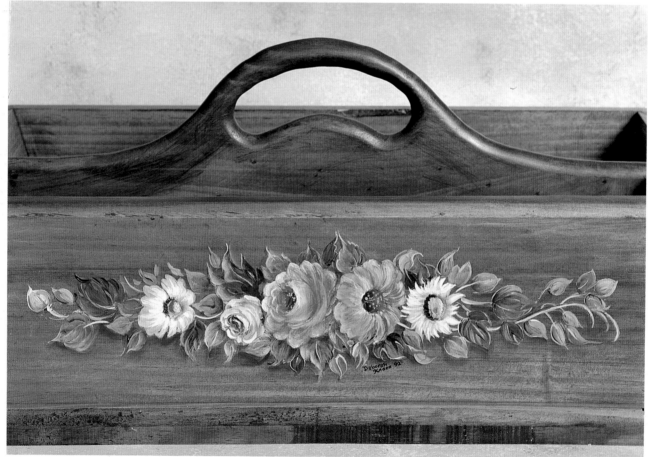

Close-up: cutlery box

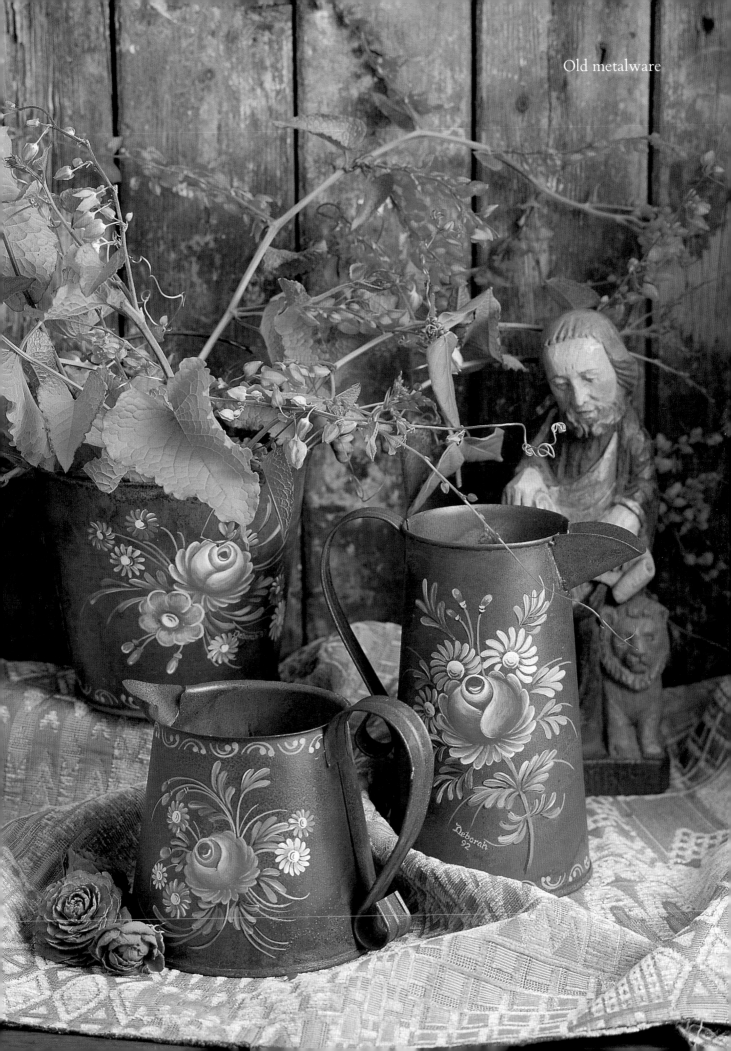

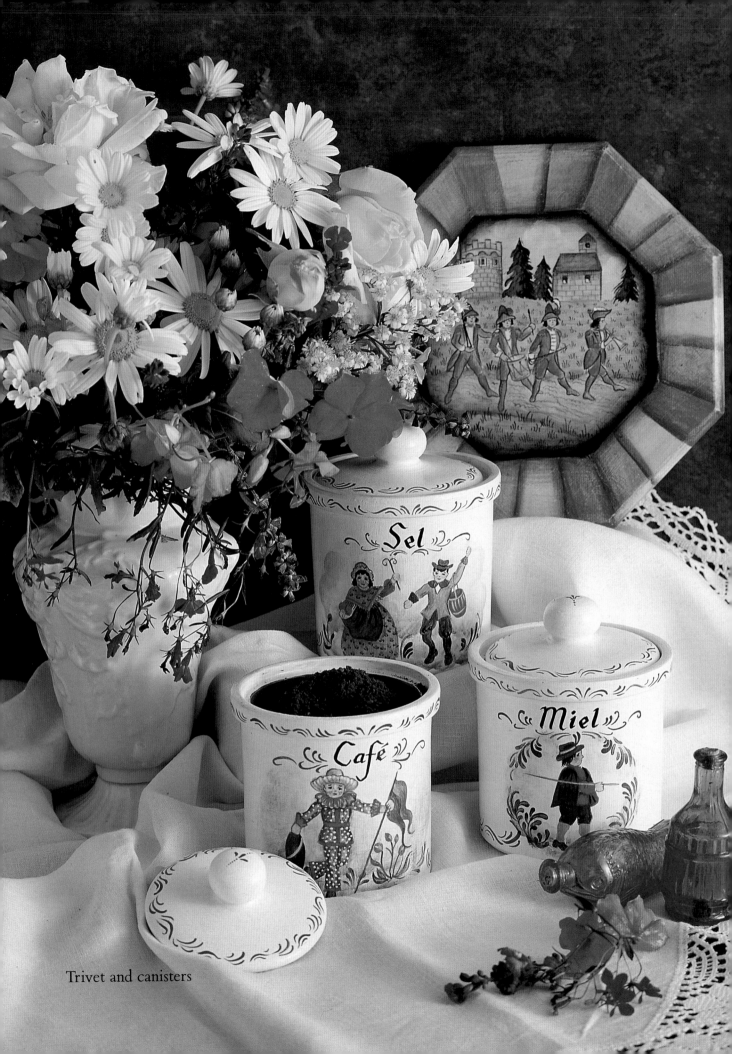

Trivet and canisters

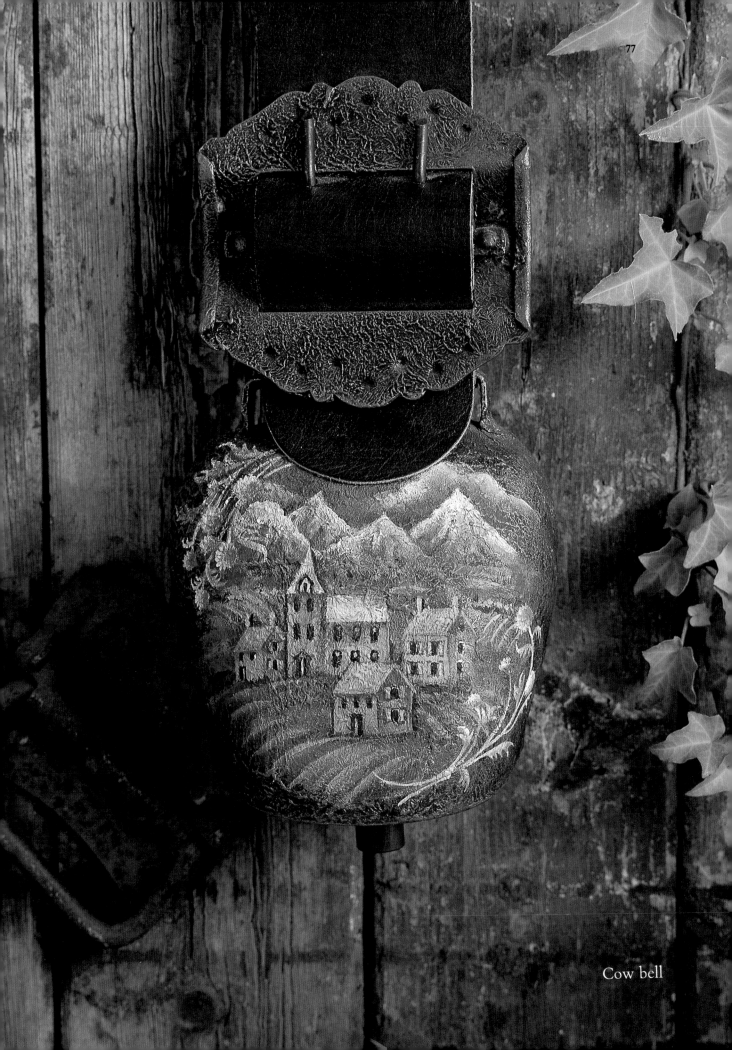

Cow bell

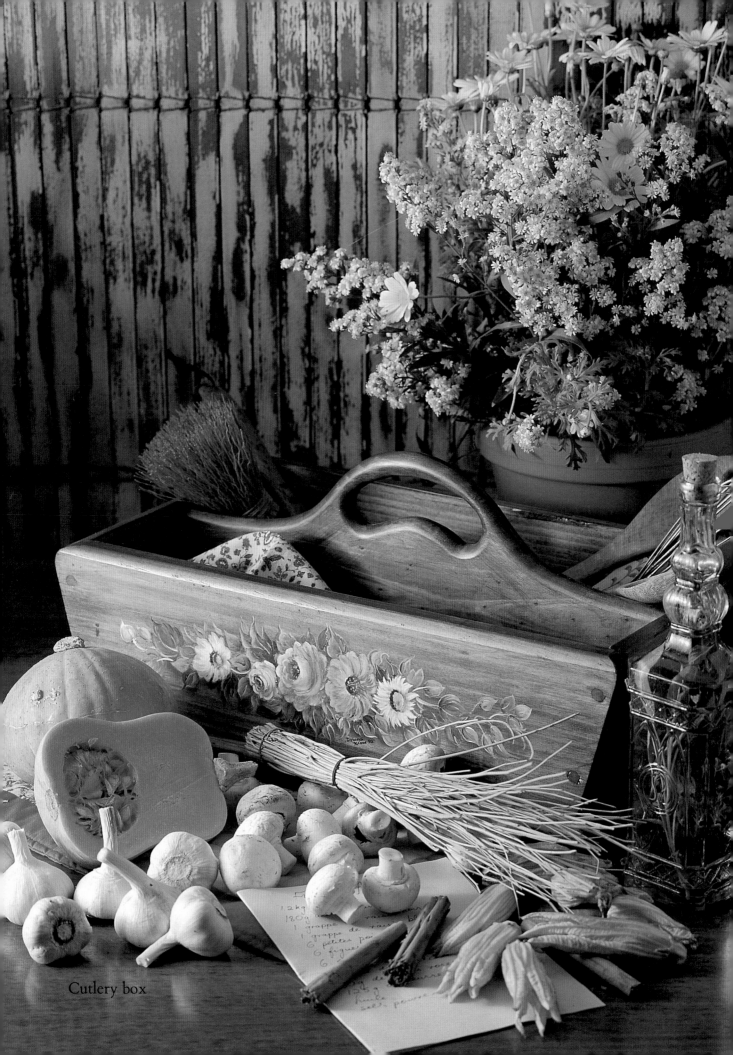

Cutlery box

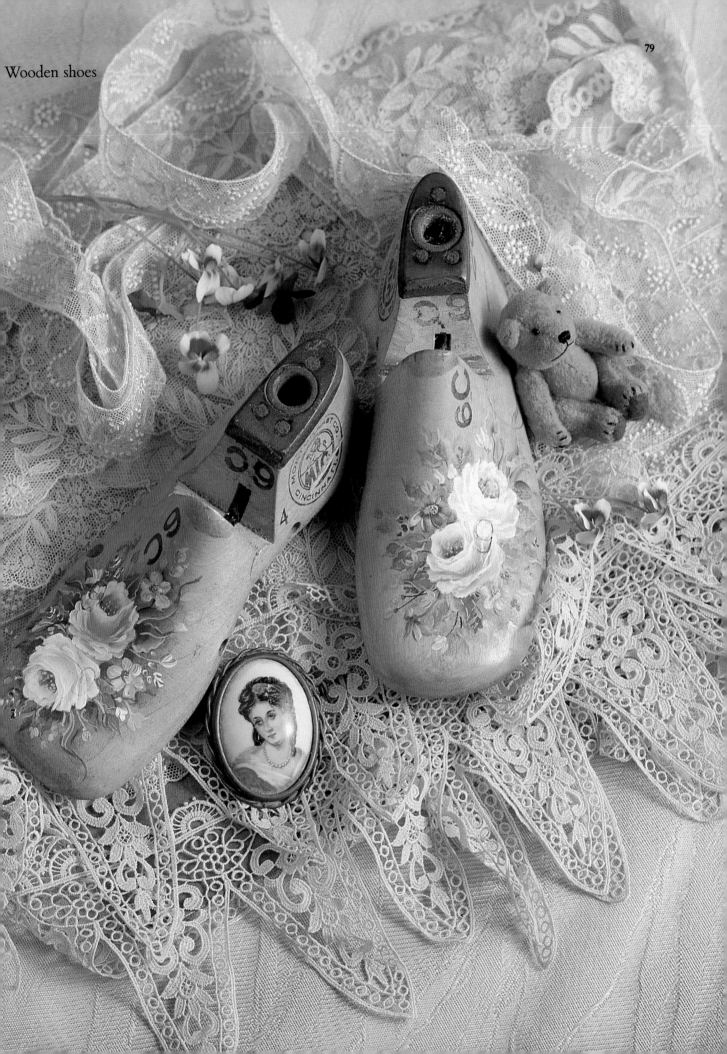

La Carte
chez nous

Chèvre chaud
et sa salade

Gigot d'agneau

Oeufs à la neige

Deborah Kneen 93

Deborah Kneen '93©

LEAVES

Leaves are brush-mixed or double-loaded. Try combinations of Pine Green with:

- Turner's Yellow.
- Warm White.
- Brown Earth.
- Red Earth.
- Norwegian Orange. (Don't paint too many of these.)

Wash in some Brown Earth at the base of the leaves and where they disappear behind a flower.

With a liner brush, outline some of the leaves with Warm White plus Pine Green and add flowing stems of the same colour.

FLOATED SHADING

With the flat brush, float Brown Earth shadows under the leaves and flowers to make them look an integral part of the box. If the shadow is not strong enough, add a little Carbon Black to the Brown Earth.

FINISHING

Varnish (painted area only) with one or two coats of water-based matte varnish.

WOODEN SHOES

Je vous entends venir avec vos gros sabots.

Old French saying

(Literally: I can hear you coming in your big wooden shoes. Meaning: It's easy to see what you're up to!)

I hate the French because they are all slaves, and wear wooden shoes.

Oliver Goldsmith (1728–1774), *Distresses of a Common Soldier*

Wooden shoes known as *sabots* were popular footware for French farmers. They are rarely worn today, except for festivals. Our antique wooden shoe lasts are child size. The design is painted on the original background, emphasising the rich patina of the wood.

MATERIALS

Paints
Brown Earth, Dioxazine Purple, Warm White, Rose Pink, Turner's Yellow, Pine Green, Carbon Black, Napthol Red, Light Grey Blue and Burgundy Red (see Chart, page 132).

Brushes
No. 2 round brush. No. 6 flat brush (or angle shader). No. 00 liner brush.

PREPARATION
Wipe the shoe to remove dust. No other preparation should be necessary.

TRANSFERRING THE PATTERN

It is best to work this design freehand. Use your chalk pencil to sketch on circles to indicate placement of the roses.

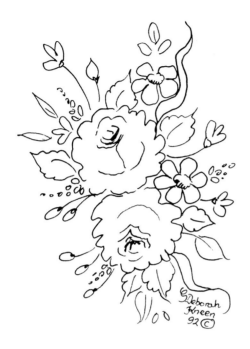

DECORATING

BACKGROUND WASH

With the round brush, paint a soft wash of Brown Earth plus Dioxazine Purple around the circles you have sketched and in the area where the leaves and filler flowers will go.

ROSES

Base the pink roses with Warm White plus Rose Pink and a touch of Napthol Red. Base the yellow rose with Warm White plus Turner's Yellow. Allow to dry.

The bowl and petals are painted with a double-loaded No. 6 flat (or angle shader). The double-loading colours are the same colours used for blocking in the roses. Vary the pink roses, if you like, by mixing a little Turner's Yellow into the Rose Pink or experimenting with your own colour mixes.

Remember to place the corner of the brush loaded with Warm White towards the edge of the petal.

When the first bowl is dry, paint a second bowl. Paint at least two rows of top petals. Then stroke in the side and bottom petals. Note that they overlap.

Still using the flat brush, float in a throat of Burgundy Red. With a liner brush, paint tiny Turner's Yellow dots in the throat.

LEAVES
Leaves are painted with a round brush in combinations of Pine Green plus Carbon Black or Turner's Yellow.

FILLER FLOWERS
Filler flowers are painted with a double-loaded round brush. Try Dioxazine Purple and Warm White or Light Grey Blue and Warm White. Centres are Turner's Yellow, shaded with Brown Earth. Dot flowers are Rose Pink and Burgundy Red with a touch of Warm White.

FINISHING
Finish with water-based matte or satin varnish.

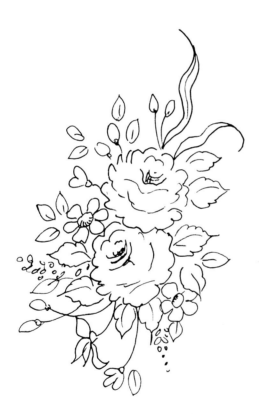

MENU BOARD
WITH CHERUBS

Un cuisinier, quand je dîne,
Me semble un être divin
Qui, du fond de sa cuisine,
Gouverne le genre humain.

Marc-Antoine Desaugiers (1772–1827)

(He who cooks food for me, seems like a divine being who rules the human race from the depths of his kitchen.)

Man did eat angel's food.

Psalms 78:25

The idea of a card listing in order the names of all the dishes in a meal dates back to 16th century France. These bills of fare were working menus, indicating to the kitchen staff of a royal or wealthy household the order in which to serve the many courses for a grand dinner.

Restaurant menus, as we know them today, originated in the early 19th century in the restaurants of Paris. It was customary for each restaurant to have a large hand-painted poster or board at the door, artistically decorated and inscribed with the names of the dishes on offer. These menu boards eventually became much sought after by collectors.

Cherubs are one of the most common motifs in French painted decoration, appearing on ceilings, walls, furniture and ceramics. They can be rendered with the finesse of a master painter such as Boucher, or, at the other extreme, as *personnages grotesques*. For instance, the cherubs I found on a 17th century faience oyster platter from Montpellier (Musée Fabre) are not all angelic; they look more like crudely drawn caricatures, their faces resembling satyrs.

The cherubs we will paint fall stylistically between these two extremes. They are adapted from an 18th century painted ceiling in the Museum of Old Aix at Aix-en-Provence.

Your menu board will undoubtedly add a unique touch to special dinner parties.

MATERIALS
Paints
Opal, Rich Gold, Pine Green, Rose Pink, Red Earth, Warm White, Brown Earth, Turner's Yellow, Norwegian Orange, Napthol Red, Flesh Colour and Burgundy Red (see Chart, page 132).

Brushes
Large flat brush for pickling. No. 2 round brush. No. 00 liner brush. No. 6 or 8 flat brush.

Extras
Retarder/extender. Old toothbrush.

PREPARATION

PICKLING
Mix Opal and retarder to a runny consistency and use a base-coating brush to pickle the frame and shelf. Let dry. Repeat, if necessary.

SPATTERING
Cut a piece of paper to the size of the blackboard and place over it as protection from spatters.

Take an old toothbrush and lightly spatter the frame, using Rich Gold diluted with water. If you are new to spattering, practise first on paper. As extra insurance against disasters, you could apply one coat of water-based matte or satin varnish to the frame prior to spattering. Mistakes can then be easily removed.

TRANSFERRING THE PATTERN
Transfer the design with white transfer paper for the blackboard area and grey for the frame. Keep your lines light as they will be hard to cover. The full fabric design is not included in the pattern, but is easy to sketch on with a chalk pencil.

DECORATING
Unless otherwise stated, all steps use a No. 2 round brush. Refer to the step-by-step guide on page 36.

WASHES
Paint a soft wash of Pine Green around each of the flower bouquets on the frame. It does not matter if the wash goes over the pattern lines.

ROSES
Follow the instructions for the Loire Valley rose on page 72. Then, as a finishing touch, use the flat brush to float Burgundy Red at the base of the bowl and on the edges of down-turned petals.

OPEN YELLOW-ORANGE FLOWERS
Follow the instructions for the open yellow-orange flower on page 72.

DAISIES
Paint the petals Warm White and the centres Norwegian Orange.

FILLERS
Filler flower petals are double-loaded Rose Pink and Turner's Yellow. Vary the mixture for each flower. Centres are Brown Earth. When dry, use a liner brush to casually outline the flowers with Warm White.

LEAVES AND STEMS
Follow the instructions for leaves on page 82.

CHERUBS
Because the cherubs are on a dark background, they will require several coats of Flesh Colour. Apply the paint smoothly and avoid ridges.

Use a No. 6 flat brush to float shadows of Norwegian Orange plus Flesh on the skin. Highlight with floats of Warm White.

Hair is base coated with curly strokes of double-loaded Warm White and Turner's Yellow. When dry, add extra liner strokes of straight Warm White. Paint a few fine Brown Earth curls here and there.

Eyes, eyebrows and nose are painted in Brown Earth, using a liner brush. Lips are watery Red Earth.

Shade where the hair meets the forehead with a very soft wash of Red Earth. Highlight centre of forehead, tops of cheeks, chin and nose with watery Warm White.

Wings are painted watery Warm White. They should be transparent. Allow to dry and then paint opaque Warm White overstrokes.

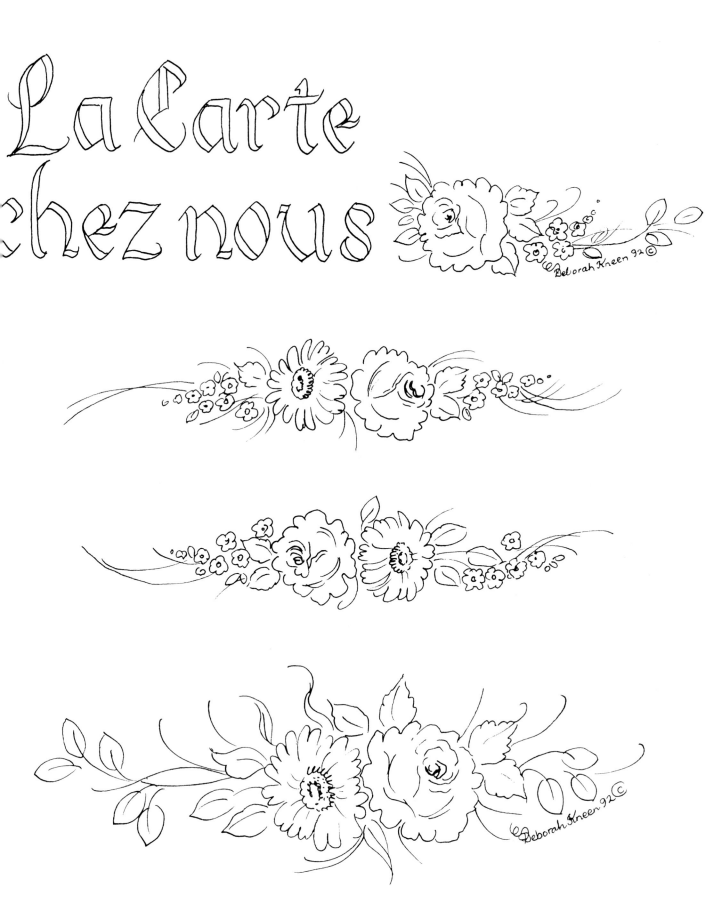

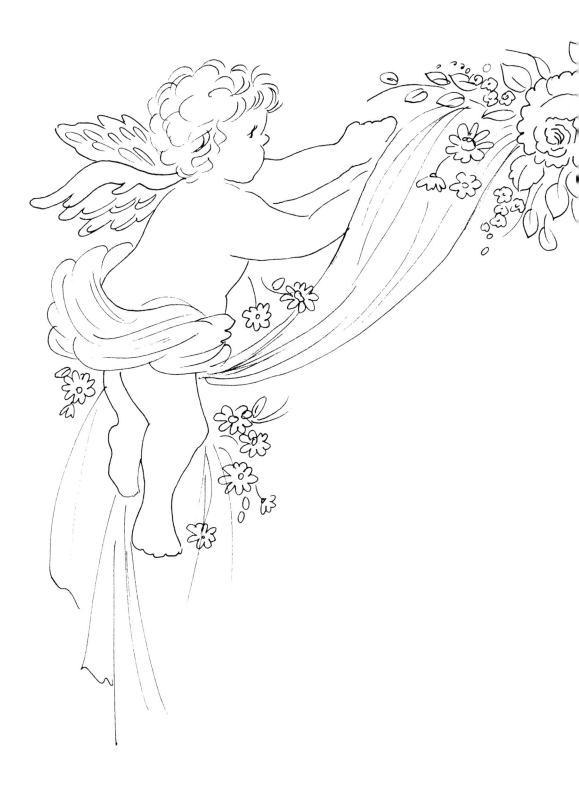

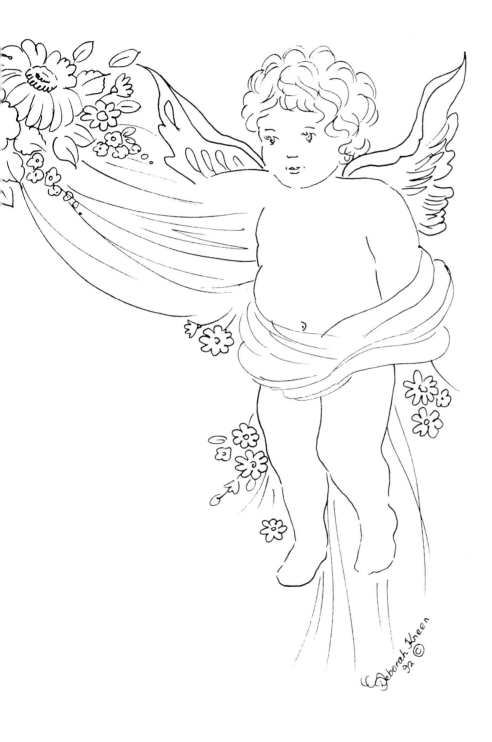

FABRIC SWATHES

The fabric is painted with washes of Warm White. Allow the paint to build up to form folds. Let dry. If the fabric is too light, repeat the washes. Outline at random with Warm White. Make the lines fine and flowing.

LETTERING

Using a liner brush, carefully paint the lettering Burgundy Red. When dry, take a flat brush and float Brown Earth over the bottom third of the letters. Rub with a cloth to soften the colour.

To personalise the menu board, instead of writing *chez nous* (at our place), write the person's name after *chez*. Adjust the position of the second row of lettering so that it is centred.

ANTIQUING

Mix Brown Earth and water to a runny gravy consistency. Working an area at a time, paint this mixture over the flowers, fabric swathes, cherubs' wings, etc, but keep it off the faces which will tend to look dirty if antiqued. For the same reason, go lightly over the other flesh areas. Whilst the wash is still wet, rub off gently with a damp cloth.

FINISHING

Paint or rub watery Rich Gold around the edges of the frame, as shown in the photograph.

Varnish the frame with water-based matte or satin varnish. Do not varnish the blackboard area as chalk will not take over varnish.

Write your dinner party menu with a chalk pencil — the same pencil you use for sketching designs. It's easier to use than a stick of chalk. If you are painting the menu board as a gift, include a chalk pencil with it, attached by ribbon or cord to a small hook screwed into the side of the shelf.

My menu, by the way, is hot goat cheese, followed by baked lamb and, for dessert, snow eggs (soft meringues floating in custard and topped with spun sugar).

Bon appétit!

OFFEE GRINDER
WITH OLD SEVRES ROSES

Chaque fleur est une âme à la Nature éclose.

Gérard de Nerval (1808–1855)

(Each flower is the soul to blossoming nature.)

The roses on this coffee grinder require both round and flat brush skills. Strictly speaking, they are not *décor folklorique* but I thought the project was too pretty to omit.

 Our Sèvres roses date from the mid 18th century and appear on the china of Mesdames de Pompadour and du Barry. By the early decades of the 19th century, Sèvres roses had become very complex with multiple bowls and intricately worked petals which take them beyond the realm of the folk artist. To distinguish between the two styles, I have dubbed the mid 18th century variety 'Old Sèvres' roses. A step-by-step guide on page 34 will help you to master the techniques.

MATERIALS
Paints
Warm White, Rose Pink, Napthol Red and Burgundy Red (see Chart, page 132), Brown Earth, Turner's Yellow, Pine Green, Rich Gold.

Brushes
No. 2 round brush. No. 00 liner brush. No. 6 flat brush or small angle shader.

Extras
Retarder/extender.

PREPARATION
No surface preparation is needed. You can paint directly onto the metal and wood, but note the comments below.

TRANSFERRING THE PATTERN

Chalk pencil and transfer paper do not work well on these surfaces so you may have to 'sketch' on the design with paint and a small round or liner brush. When doing this kind of designing, use a light neutral such as Smoked Pearl. Because the surfaces are slightly glossy, any mistakes can be easily removed.

DECORATING

ROSES

Block in the roses using a pale pink made with Warm White and a little Rose Pink and Napthol Red. Paint each rose, a section at a time using strokes that follow the shape. Allow to dry.

Dip the flat brush into retarder and blot any excess on a soft cloth. Double load the brush with Warm White and Rose Pink. Blend on a firm surface such as a tile until the two colours merge at the centre of the brush. With the Rose Pink facing downwards, paint the bowl of the rose. You need not do this in one stroke. If you make two strokes, it will create an interesting split bowl effect. Let dry.

Paint the petals the same way but place the Rose Pink corner of the brush towards the centre of the rose.

When dry, assess the roses and, if necessary, repeat the double-loaded strokes.

Paint in the dark part of the throat with a flat brush float of Burgundy Red. With your round brush, pat in some Brown Earth at the very darkest part of the throat.

Now add extra highlights and shadows with the round brush. Place a tiny wash of Warm White on the centre of each petal and towards the top of the bowl. Smudge with your finger (or a cotton bud) if the washes are too strong.

Wash in some Burgundy Red at the base of the bowl and on the down-turned edges of the petals.

With a liner brush, add a fine Warm White frilly edge to the top of the bowl. If you want to create a second bowl, paint a second curved line just below the first. On some of the roses I carried this line down onto the bowl to suggest a split bowl.

Add some fine semi-circular lines in Warm White or Turner's Yellow to the throat and a few very tiny dots of the same colour.

Take a round brush double-loaded with Pine Green and Turner's Yellow or Pine Green and Warm White and paint in the leaves. Start from the base of the leaf and work up to the point, one side at a time. Allow the double-loaded colour to create veins.

When dry, use the flat brush to float Turner's Yellow or Warm White, or a combination of both on the edges of the leaves.

CAFÉ

Remember that the edges are serrated so jiggle your brush. Float Brown Earth at the base of some of the leaves, particularly where they disappear behind the roses.

With a liner brush, paint very fine central veins of Warm White plus Pine Green. These should be barely visible. Stems are the same colour.

DAISIES
Using the round brush, paint the daisy petals Warm White. One coat is sufficient — they need not be opaque. Centres are Turner's Yellow. Paint a solid Brown Earth dot in the very middle and tiny Warm White dots over the yellow part of the centre. Take the flat brush and float Brown Earth around the centre at the base of the petals.

FILLER FLOWERS
Paint the little filler flowers Warm White. Keep the colour semi-transparent so that the flowers look light and delicate. Centres are Turner's Yellow, shaded at the base with Brown Earth.

The tiny rose buds are Rose Pink plus Warm White. Leaves are combinations of Pine Green, Warm White and Turner's Yellow.

TRIMS
Add fine Rich Gold lines and bands, as appropriate. I also floated Burgundy Red around some of the mouldings and edges.

With the liner brush, paint the lettering Warm White and shadow-outline it with Burgundy Red.

FINISHING
Varnish with water-based matte or satin varnish.

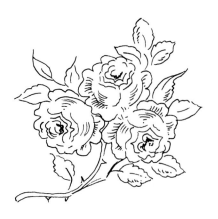

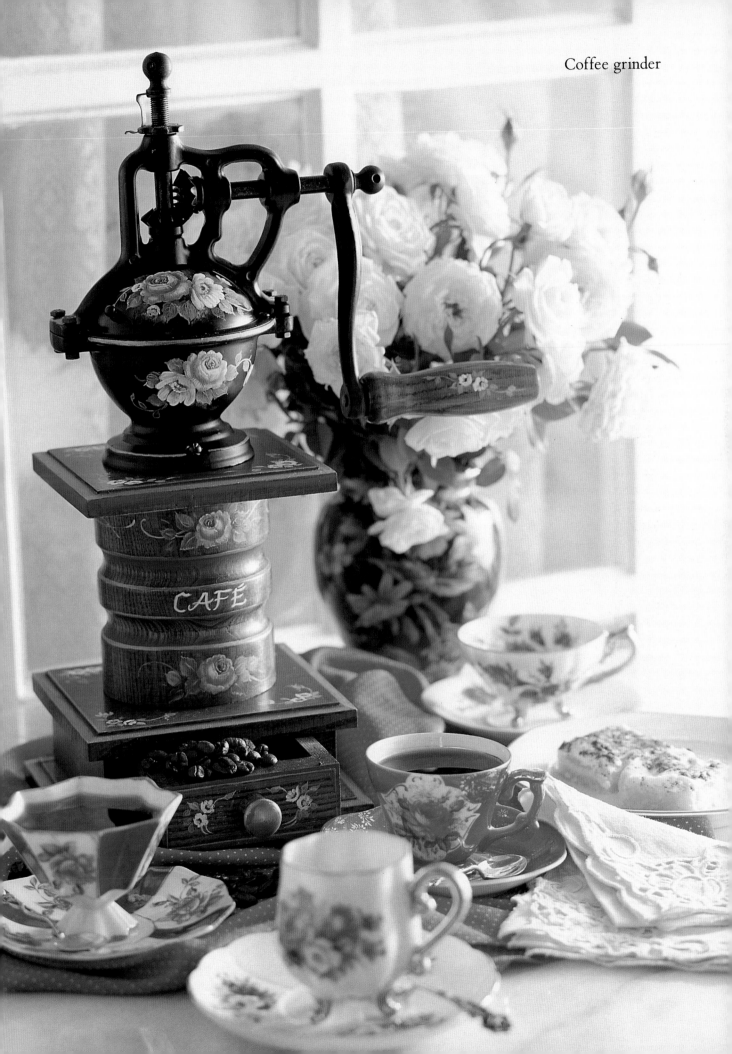

Close-ups: menu board and coffee grinder

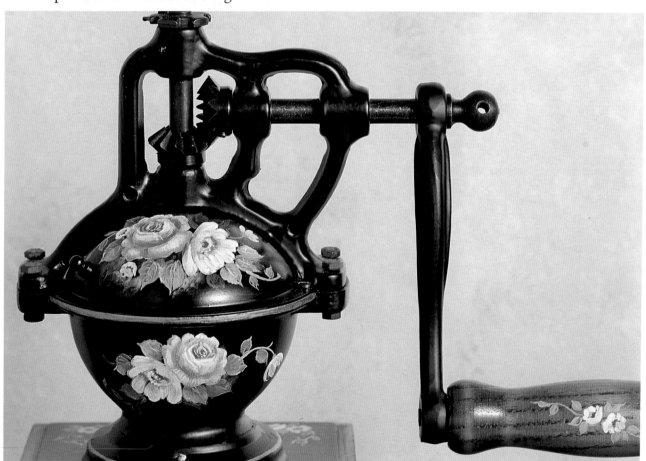

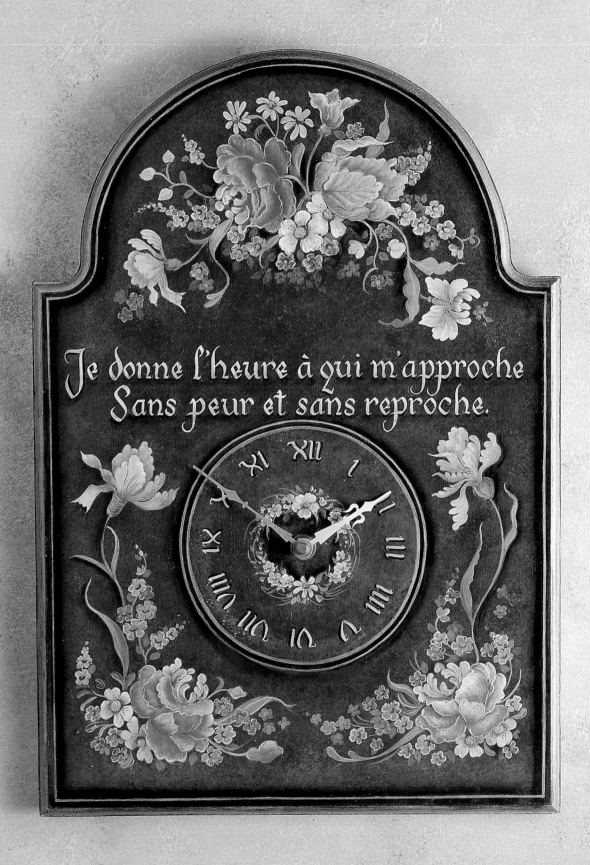

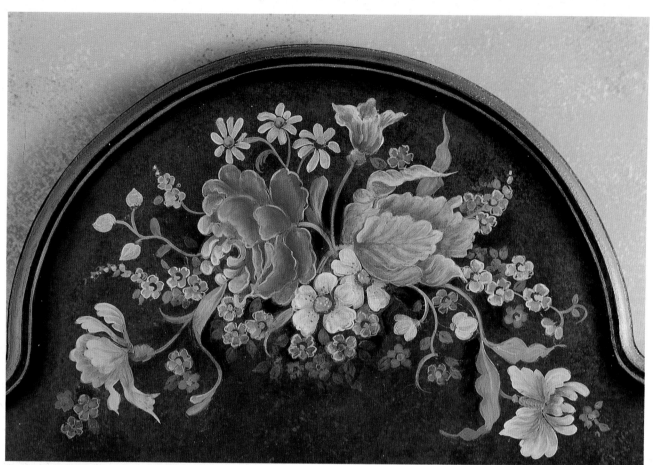

Close-ups: clock and canisters

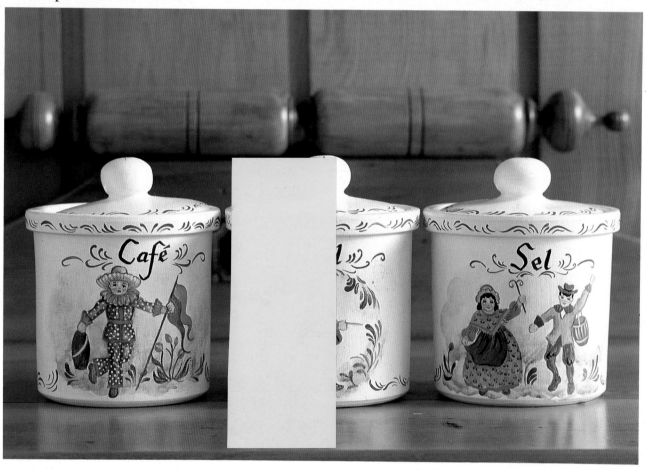

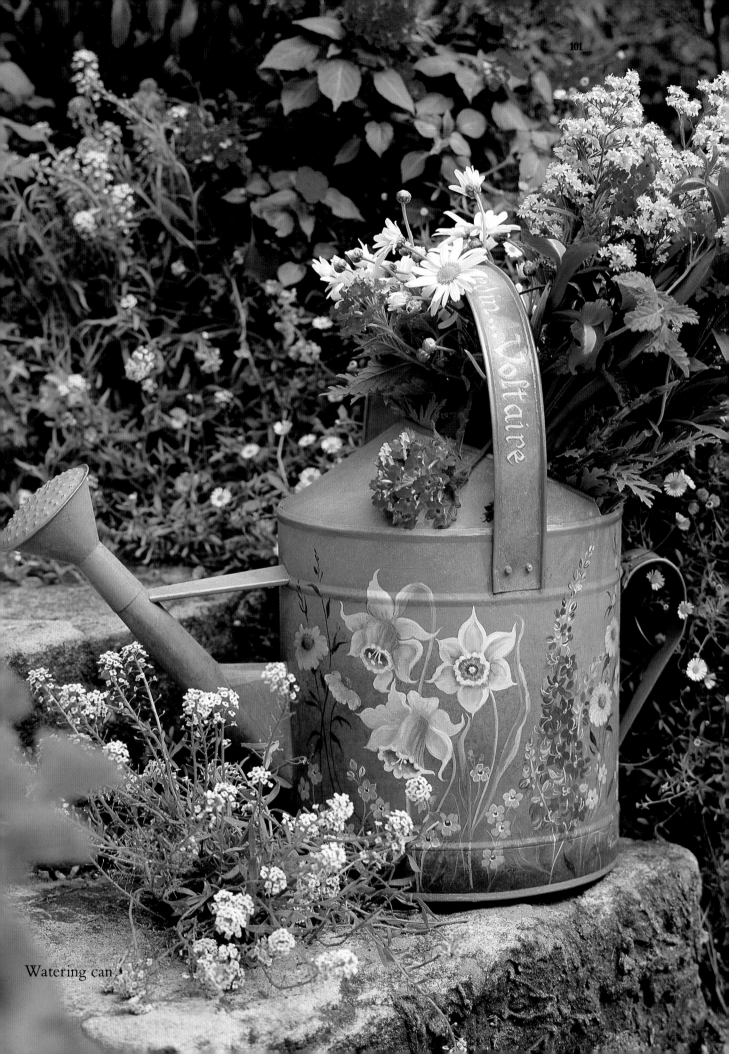

Watering can

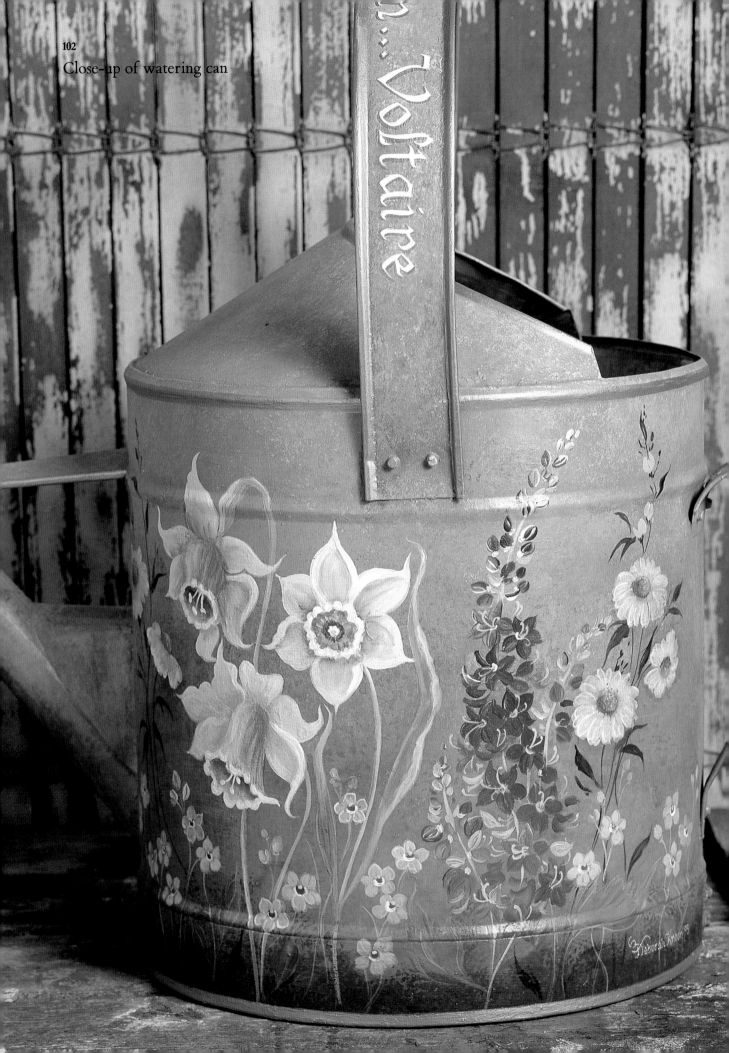

Close-up of watering can

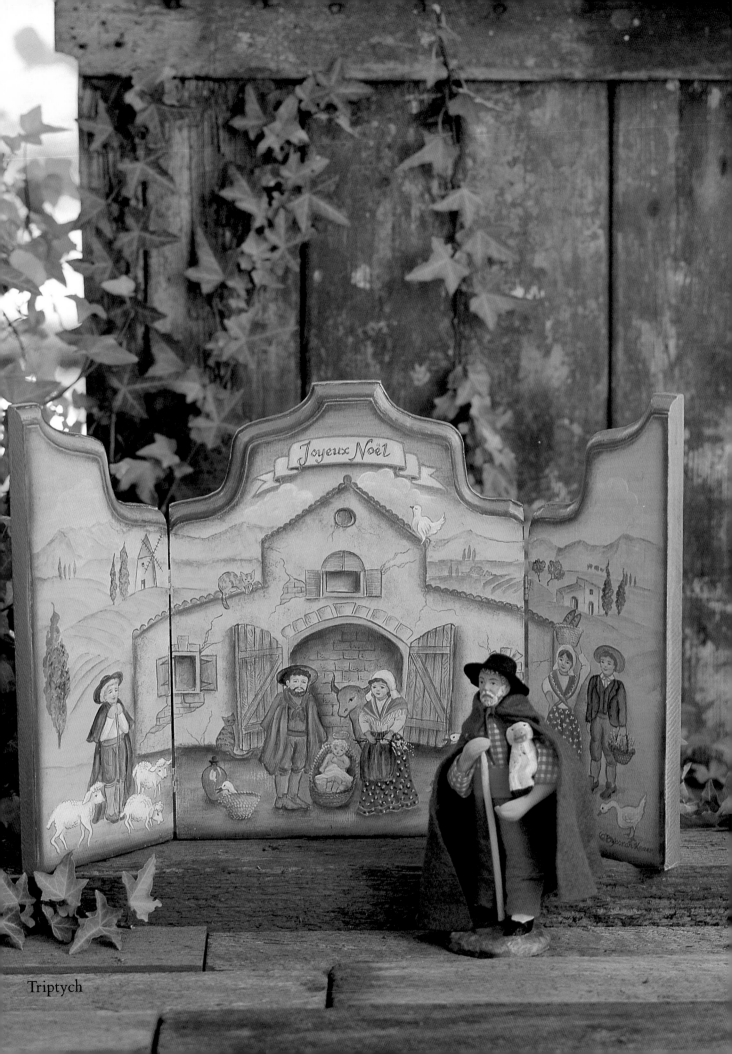

Triptych

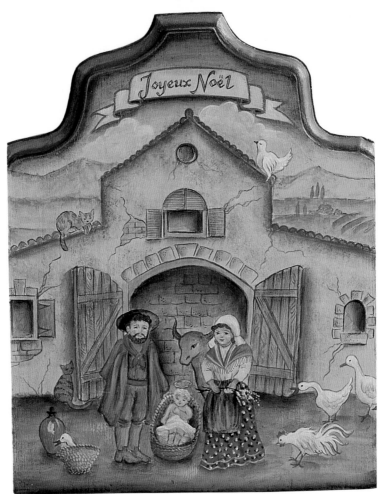

Close-ups of triptych

SET OF CANISTERS IN
IN THE FAIENCE STYLE

I met a traveller from an antique land.

Percy Bysshe Shelley (1792–1822)

**Au clair de la lune, mon ami Pierrot,
Prête-moi ta plume pour écrire un mot...**

Traditional French folk song

(By the light of the moon, my friend, Harlequin, lend me a pen to write a word.)

The singers went before, the players on instruments followed after.

Psalms 68:25

Here is a group of typical *personnages grotesques* from the faience world: a traveller, a harlequin and a pair of itinerant entertainers. The colours used are limited to the traditional palette of the 17th century.

French antique shops and folk museums are a treasure trove of old kitchen items, including charming sets of earthenware canisters (*pots* pronounced 'poe'), depicting scenes of rural life and labelled with the names of staple food items.

In this project I have tried to simulate the look of traditional glazed faience by using a white background and varnishing the finished pieces with water-based gloss varnish.

MATERIALS
Paints
Titanium White, Flesh Colour (see Chart, page 132), Brown Earth, Napthol Red (see Chart, page 132), Carbon Black, Yellow Oxide, Ultramarine, Pine Green.

Brushes
Sponge brush for base-coating. No. 2 round brush. No. 6 flat brush. No. 00 liner brush.

PREPARATION

Ensure the surface is smooth and free of dust. Mix approximately two parts of Titanium White to one part All Purpose Sealer and base coat the outside surfaces of the canisters. (See page 139.) Since the bisque surface is already white, you will have no problems with coverage.

TRANSFERRING THE PATTERN

Transfer the design with grey graphite transfer paper, preferably an old sheet, so as to avoid smudges.

DECORATING

FIGURES

Use the No. 2 round brush and No. 00 liner brush to paint the figures. All faces and hands are Flesh Colour. Facial features are Brown Earth. Cheeks are blushed with a watery spot of Napthol Red. Tops of cheeks, noses and foreheads are highlighted with a tiny wash of Warm White. Hair is Brown Earth plus Carbon Black. Hands are finely outlined with Brown Earth. Outline the figures, as desired, with Brown Earth.

When colouring in the clothing, keep the paint slightly watery. All the figures have Brown Earth shoes.

LITTLE TRAVELLER (PETIT VOYAGEUR)
Hat: Brown Earth.
Hat band: Yellow Oxide.
Feathers: Ultramarine.
Cape and shoes: Brown Earth.
Shirt: Napthol Red.
Breeches: Pine Green plus Yellow Oxide.
Stockings: Yellow Oxide plus a touch of Brown Earth.
Stick: Brown Earth plus Warm White.
Comma stroke leaves: Pine Green plus Yellow Oxide.

'Petit voyageur' (Little traveller)
Montpellier C17th (tile)

HARLEQUIN (*PIERROT*)

Hat: Yellow Oxide. Highlight the hat with Warm White and outline in Brown Earth.

Frills at neck and sleeves: Napthol Red. Highlights and outlining as for hat.

Jacket and trousers: Pine Green plus Yellow Oxide.

Polka dots: Yellow Oxide plus Warm White.

Bands: Napthol Red.

Drum: Brown Earth with Yellow Oxide band.

Flag: Napthol Red, Ultramarine.

Pole: Brown Earth.

Comma leaves: Pine Green plus Yellow Oxide.

Flowers: Napthol Red with Yellow Oxide centres.

Moustiers C18th (pot)

TRAVELLING ENTERTAINERS
DAMSEL

Bonnet, shawl and underskirt: Yellow Oxide. Shade with Yellow Oxide plus Brown Earth. Bonnet outlined in Brown Earth. Napthol Red dot flowers with Pine Green leaves on shawl and skirt.

Sleeves: Napthol Red.

Moustiers C18th (vase)

DRUMMER

Hat: Brown Earth with Carbon Black band.

Jacket: Yellow Oxide plus a touch of Brown Earth. Pine Green collar and cuffs.

Breeches: Brown Earth.

Stockings: Pine Green plus Yellow Oxide.

Drum: Napthol Red, detailed with Yellow Oxide and a Brown Earth top.

WASHES FOR SKY AND LAND

Before painting the washes for the sky and land, it is best to apply one coat of water-based matte or satin varnish. This prevents the washes 'grabbing' the surface and looking harsh. Ensure first, however, that all visible pattern lines have been erased, and any smudges removed or covered with the Titanium White base colour.

For the land, side load the No. 6 flat brush with watery Pine Green and swirl on the colour. Blot with a cloth if it is too strong. Repeat for the sky, using Ultramarine.

LETTERING

Use a liner brush to paint the letters black green (Pine Green plus Carbon Black).

My canisters are labelled *Miel* (honey), *Sel* (salt) and *Café* (coffee). You might prefer to have other items such as *Ail* (garlic), *Sucre* (sugar), *Thé* (tea), *Farine* (flour), *Riz* (rice).

BORDERS

The casually scrolled borders are painted Ultramarine, using a small round or liner brush. Unlike the Germans and Scandinavians, the French are very relaxed about these kind of borders so try to paint freehand and don't worry if strokes vary a little in size and thickness. Keep the paint flowing well by adding water.

FINISHING

Finish with at least six coats of water-based gloss varnish such as J. W.'s Right Step or Delta Ceramcoat 7004. Do not place lids on canisters until the paint and varnish have hardened and cured — two or three weeks — otherwise the paint on the rims may lift.

AVOIE CLOCK

Je donne l'heure à qui m'approche,
Sans peur et sans reproche.

The verse also rhymes when translated:

I give the time to those who approach,
Without fear and without reproach.

As we were driving through the town of Pontcharra in Savoie,
I caught sight of a clock tower painted with the inscription above.

 Painted verses on buildings, although common in southern
Germany, Austria and Switzerland, are rare in France, so I was
thrilled to find this one and immediately set about planning a
clock project to incorporate it.

 The Savoie clock, decorated with 18th century *fleurs au naturel*
is the result. These flowers are among the most difficult of the
décor folklorique florals and require lots of blending. You will find
that using retarder will help to create the delicate, naturalistic
effect. The flowers are placed on an elegant sponge-marbled
background.

MATERIALS

Paints
Black Green, Medium Blue-Green, Napthol Red, Burgundy
Red, Light Grey-Blue (for all preceding colours, see Chart,
pages 132, 133), Opal, Rose Pink, Norwegian Orange, Warm
White, Turner's Yellow, Brown Earth, Pine Green, Rich Gold.

Brushes
Base-coating brush. No. 2 or 3 round brush. No. 00 liner brush.
No. 6 or 8 flat brush.

Extras
Sponge. Compass. Retarder/extender.

PREPARATION AND BASE COATING

Sand well, particularly the edges. Base coat with two or three coats of Black Green.

SPONGE-WASH MARBLING

Wet a piece of sponge and squeeze out excess water. Mix Medium Blue Green with water to make a runny mixture. Place the sponge in the mixture, then blot on a piece of paper to remove excess paint and to test the sponging pattern. The sponging should be watery, not opaque. Now sponge over the Black Green base colour. Allow to dry. The sponging should be quite soft and subtle. Sponge more heavily in the area of the clock face.

TRANSFERRING THE PATTERN

Carefully transfer the pattern, using white transfer paper. Use a chalk pencil and compass to draw the circular clockface. Place a small piece of Blu-Tak in the central hole and insert the pointed end of the compass.

HINTS FOR BLENDING WITH RETARDER

Place a few drops of retarder in a shallow, open-mouthed container such as a jar lid. Add to your brush, as required, to aid blending and slow drying time. Do not work a particular area too long. Let it dry, then come back to it. At the end, if a flower looks uneven, a final retarder wash of an appropriate light- to medium-value colour will draw everything together.

DECORATING

GENERAL TIPS

Use the No. 2 or 3 round brush, unless otherwise stated.

The colour on all these flowers is diluted a little with retarder.

Refer to the step-by-step guide to *fleurs au naturel* on page 35.

I suggest that you continue to add layers of highlights and shadows on each flower until you are satisfied with the result.

ROSE

Base in the sections of the rose using a brush mix of Opal and Napthol Red. Take the flat brush and float in the shadows at the base of the bowl, throat and so on with Burgundy Red.

Again with the flat brush, highlight the edges of the top petals with Opal. When dry, lightly wash over the rose with Rose Pink and a touch of Norwegian Orange. Then brighten highlights, if necessary.

Finely outline the rose petals in Warm White plus Opal, using a No. 00 liner brush.

TULIP

Base in a thin coat of Opal, allowing the background colour to show through. Work a petal at a time. Stroke in the contours with thicker Opal. Let dry.

With the flat brush, float Burgundy Red at the base of the tulip and on back petal. Burgundy Red can also be floated over the contours. Allow to dry. Paint a final wash of Opal plus Rose Pink over the tulip.

Highlight the tips of the petals with Warm White plus Opal.

CARNATIONS

Paint each petal with strokes of Opal plus Rose Pink. Give the front petals a second coat. Note that the carnations can be painted with thicker paint consistency than the other flowers. Shade and wash as for the tulip. Float flat brush highlights of Warm White plus Opal at the frilly tips of the petals.

FORGET-ME-NOTS

Base petals in Light Grey-Blue. Centres are Turner's Yellow, outlined with a Brown Earth semi-circle. Use a liner brush to outline some of the petals with Warm White.

Paint some watery 'shadow' forget-me-nots. They are indicated on the pattern with dotted lines.

PRIMROSES

Petals are washed in with Warm White. Centres are Turner's Yellow plus a touch of Pine Green. When dry, paint tiny dots of Warm White on the centre. Paint Burgundy Red dots on some of the petals.

With the flat brush, float Burgundy Red lightly around the base of the petals.

Ouline some of the petals with Warm White, using a liner brush.

DAISIES

Paint the petals Warm White. The paint should be a creamy consistency to make the daisy strokes. Centres are Turner's Yellow, outlined with a semi-circle of Pine Green.

Bonne l'heure à qui maraboch
Sans peur et sans reproche
Sordibus impacis

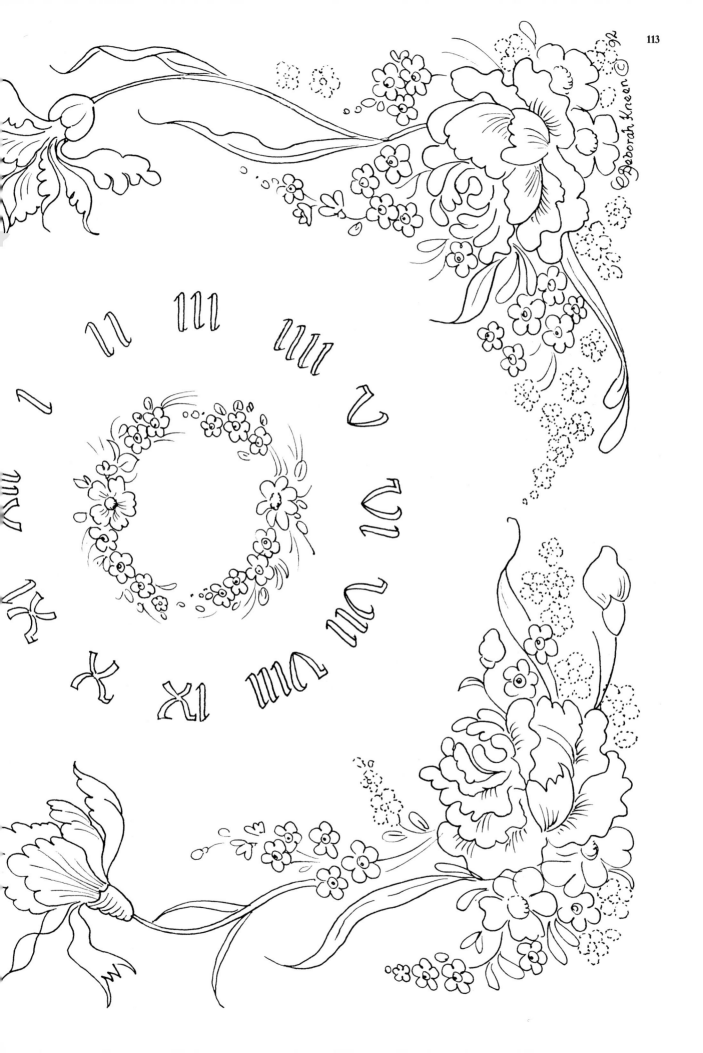

LEAVES

Leaves and calyxes are painted with Pine Green plus Warm White and/or Turner's Yellow. Highlight with washes of Warm White, particularly on the widest parts of the tulip leaves. With the flat brush, float Turner's Yellow along one edge of each leaf. Stems are painted in the same colours, with a liner brush.

CLOCK FACE

Use a liner brush for the circles and numerals. For this type of work I find that the shorter bristles of a normal liner brush give me more control than a script liner.

Outer circle is Warm White. Inner circle is Rich Gold. Numerals are painted Warm White and shadow-outlined in Black Green. The primroses, forget-me-nots and leaves in the small wreath are painted according to the instructions above.

INSCRIPTION

With a liner brush paint the lettering Warm White. Shadow outline with Black Green. When dry, use the flat brush to float Brown Earth over the bottom third of the letters.

GOLD BORDERS

Paint the routed edges of the clock with Rich Gold. Paint a fine Rich Gold line just in from the edge of the clock.

ANTIQUING AND FINISHING

Protect the surface prior to antiquing by applying one coat of water-based matte or satin varnish. Leave 24 hours. Mix Brown Earth and retarder to a very runny consistency, and work a flower at a time, remembering that the mixture dries much faster than oil antiquing. Paint the antiquing mixture on and rub it off with a damp cloth. Allow to dry.

It is better to make the antiquing too light initially and then repeat the process several times than to create a heavy brown mess which cannot be removed. If you feel that you have lost too much brightness, repaint some of the highlights, then assess whether you should apply one final light coat of antiquing. Note that if you had used an oil-based antiquing mixture, you would not have been able to paint over it with acrylics to brighten highlights.

To accentuate the shape of the clock, I ran a float of Carbon Black, butted up against the Rich Gold line which defines the

edge of the clock. A similar float could be applied around the outside of the circular clock face.

Varnish with two or three coats of water-based matte or satin varnish. Insert the movement, batteries and hands and proudly hang your clock.

WATERING CAN
INSPIRED BY MONET'S GARDEN

Il faut cultiver notre jardin.

Voltaire (1694–1778), *Candide*

(We must cultivate our garden.)

What I need most of all are flowers, always, always.

Claude Monet (1840–1926)

In the 1880s Claude Monet started creating his garden at Giverny, a little village on the south-eastern edge of Normandie, Monet's home province. It was the source of inspiration for much of his later work. After his death in 1926, the garden became overgrown and its famed water-lily ponds infested with water rats. In recent years the house, studio and gardens have been restored.

The gardens are a folk artist's delight, full of cottage flowers, rose arbours, weeping willows and climbing wisteria. And the house itself contains some interesting items acquired by Monet, such as a bedroom clock painted with dry brush florals and lacquered with *vernis Martin*. The dining room, painted in sunny yellow, houses a fine collection of blue and white Rouen faience.

It is also interesting to note that the great master himself painted on functional surfaces, including a series of door panels decorated with flowers and fruit and destined for the *grand salon* of an artist friend.

MATERIALS
Paints
Moss Green, Pine Green, Teal Green, Warm White, French Blue, Medium Blue-Green (see Chart, page 133), Nimbus Grey, Turner's Yellow, Norwegian Orange, Brown Earth, Dioxazine Purple, Carbon Black, Rich Gold.

Brushes
Base-coating brush. No. 2 round brush. No. 6 or 8 flat brush.
No. 00 liner brush.

Extras
Sponge.

PREPARATION

Read the section on metal preparation on page 58. Note that,
despite the most thorough preparation, the surface can be easily
damaged. Take care and be prepared to touch up any chips.

Base coat in a medium olive green, made with approximately
equal parts of Moss Green and Pine Green. Although this may
not seem a particularly attractive colour, once we sponge over
it, the effect will be very pretty.

SPONGING

Use a dampened sponge and runny paint to lightly sponge the
watering can to create a soft, mottled background. It is the same
sponge-wash technique used to create a background for the clock
(page 110) but this time several distinct sponging colours are used
to give a graduated effect.

Sponge the bottom third of the can with Teal Green. Keep
it soft and watery. Do not obliterate the olive green background.
Here and there take the sponging up into the central third. Do
the same on the spout and handle. Rinse the sponge but there
is no need to clean it thoroughly.

Now work down from the top of the can, using a watery
mix of Warm White plus French Blue and a tiny amount of Teal
Green. (Probably there will be enough Teal Green left in your
dirty sponge.) Again, carry some of the sponging onto the central
third of the can. Don't forget the spout and handle.

In the central third, sponge Medium Blue-Green. Again, carry
a little of this colour over into the other areas so that the gradation
of colour is soft.

You should now have a lovely, impressionistic background on
which to build the garden.

TRANSFERRING THE PATTERN

Transfer the pattern with white transfer paper. Note that the
design fits one side of the can and can be repeated on the other
side, as desired.

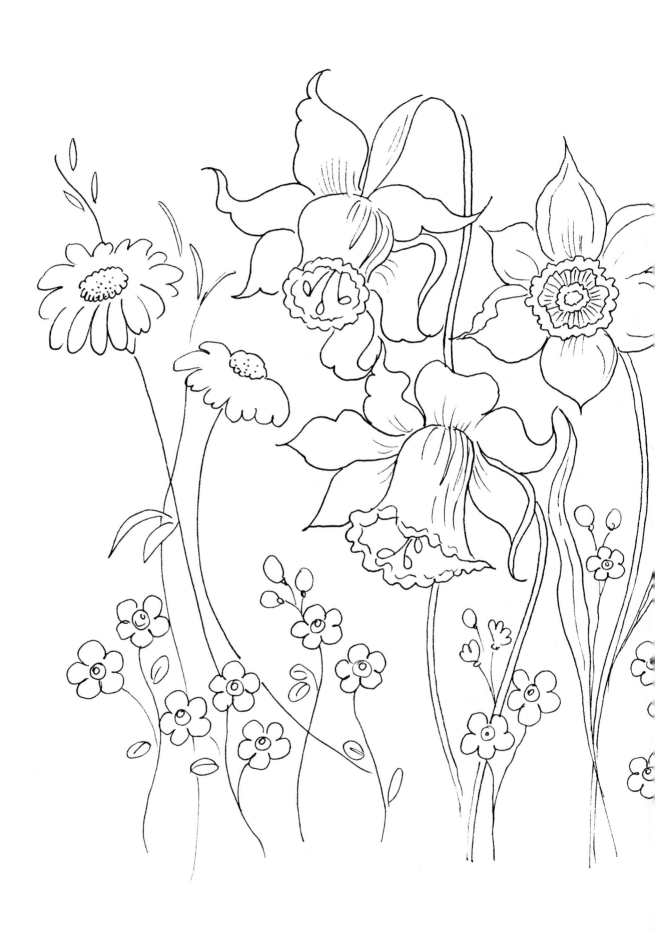

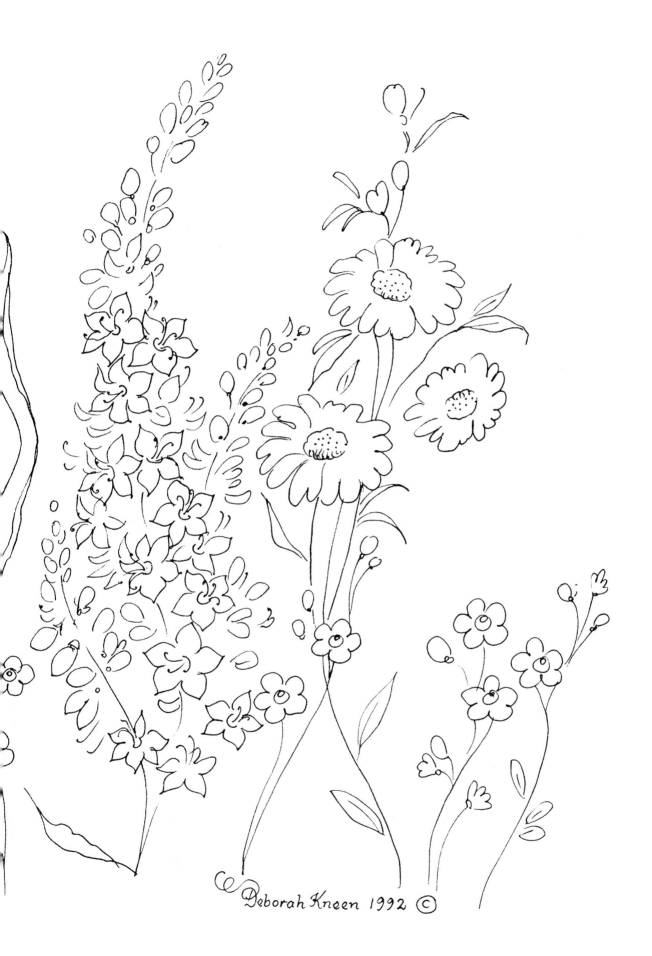

Deborah Kneen 1992 ©

DECORATING

Refer to the step-by-step guide to the Giverny flowers featured on page 37.

DAFFODILS

Base in Warm White, using the No. 2 round brush. Work a petal at a time and use strokes that follow the shapes. Three or four coats of Warm White may be needed for good coverage. Allow to dry.

Use the flat brush to float Nimbus Grey around the base of the petals and where the 'bell' joins the petals. Shade the right side of the 'bells' on the left and central daffodil, using Turner's Yellow and a touch of Norwegian Orange. With the flat brush, float Brown Earth inside the throat of these 'bells'.

Using the round brush, outline the edges of the petals of all three daffodils with Warm White, applied quite thickly. Repeat around the open edges of the 'bells'.

For the centre of the righthand daffodil, outline in a circular frill of Warm White. Cental dot is Warm White, surrounded by a circle of Brown Earth, then Turner's Yellow. Add a circle of Norwegian orange dots just inside the Warm White frill.

Apply a very subtle wash of Turner's Yellow plus Warm White over the daffodils flowers. Now strengthen the Warm White highlights, if necessary.

Stamens are painted Warm White, using a liner brush.

Stems are double-loaded Pine Green and Warm White, painted with the round brush. Leaves are done the same way. When dry, use the flat brush to float on some Turner's Yellow.

Calyxes, leaves and stems are Pine Green plus Warm White.

PURPLE VERONICA

Using the round brush, paint the flowers and buds with double-loaded Dioxazine Purple and Warm White. Vary the strengths of the two colours for each flower. When dry, paint a half circle in each centre and add two or three stamens. Use Turner's Yellow and Warm White and apply with a liner brush.

FORGET-ME-NOTS

With the round brush, paint the forget-me-not petals Light Grey-Blue. When dry, brighten the flowers, by washing a little Warm White over the petals. Centres are Pine Green. with a Warm White semi-circle at the base and a small Turner's Yellow dot in the very centre.

Calyxes, leaves and stems are Warm White with a touch of Pine Green.

DAISIES

Paint the petals with double-loaded Warm White and Turner's Yellow. When dry, use the flat brush to float Warm White around the tips of the petals. Centres are Turner's Yellow plus Norwegian Orange. Shade the centres with Brown Earth. Leaves and stems are Pine Green plus Carbon Black.

FLOATED SHADING

Take a base-coating brush or a large flat, side load with Teal Green plus Carbon Black and float a shadow around the base of the can. Ensure that the loaded corner of the brush faces towards the bottom of the can.

LETTERING

Optional: Across the handle I have written the famous line from Voltaire's *Candide:*

Il faut cultiver notre jardin.

 The letters are painted Warm White and then shadow-outlined in Rich Gold.

ANTIQUING

If you feel any of the flowers are too bright, they can be toned down by painting a very watery wash of Brown Earth over them and immediately blotting with a soft cloth. You can repeat this process as many times as you like to deepen the 'antiquing'.

GOLD TRIM

Paint Rich Gold bands around the top and bottom of the can, along the edges of the handles, around the spout and so on.

FINISHING

Protect your paintwork by finishing with six coats of water-based matte or satin varnish. As this piece is an heirloom, I do not recommend that you use it as a watering can. Similarly, do not leave it outside where it may eventually fall victim to that nemesis of all metalware — rust!

CHRISTMAS TRIPTYCH
WITH *SANTONS* OF PROVENCE

'Il est né, le Divin Enfant.'

Old French carol

(The Christ Child is born.)

The *santons* which appear in this Nativity triptych are based on 19th century figurines from the Museum of Old Aix at Aix-en Provence. *Santons* are commonly made of painted terracotta (*terre cuite*), but in the 19th century they were also painted as cardboard cut-outs. Every Provençal family has its own collection of *santons*, and most local towns have an annual *Fête de Santons* (*Santons* Fair). Fine collections of old *santons* can also be found at the Muséon Arlaten and the Museum of Old Marseilles. For more about *santons*, see page 18.

This triptych is an advanced level project, encompassing round and flat brush techniques, plus finely detailed liner work. The scene is underpainted in a warm cream, and layers of semi-transparent colour in the form of floats, washes and sponging are built up over the base colour. This underpainting technique gives the finished scene a warm glow. Since this project is complicated, read all the instructions through before you begin.

I hope that this triptych will become a very special part of your Christmas celebrations and an heirloom to be enjoyed by generations to come.

MATERIALS
Paints
Warm White, Yellow Oxide, Light Grey Blue (see Chart, page 133), Aqua, Warm White, Nimbus Grey, Dioxazine Purple, Gold Oxide, Moss Green, Pine Green, Brown Earth, Carbon Black, Flesh Colour, Napthol Red (see Chart, page 132), Turner's Yellow, Rich Gold.

Brushes
Old flat brush for base-coating. No. 2 round brush. No. 4 round brush. No. 00 liner brush. No. 10 or 12 flat brush.

Extras
Sponge. Soft cloth for blotting washes.

PREPARATION AND BASE-COATING

Sand the triptych well, particularly the routed edges, and wipe clean. Base coat with two smooth coats of cream (Warm White plus a touch of Yellow Oxide).

TRANSFERRING THE PATTERN

Trace the pattern onto tracing paper and carefully align on the triptych. Secure with Magic Tape. Slip an old sheet of grey graphite paper under the tracing. Lightly and carefully transfer the main details, but not the facial features. They will be transferred later. Ensure your pattern lines are light, as transparent techniques will be used, and pattern lines may be hard to cover.

DECORATING

SKY

Wet the sky area with water or retarder. Blot lightly with a soft cloth. Dip the No. 10 or 12 flat brush into water or retarder and corner load into Light Grey-Blue. Blend well on your palette.

Work one panel at a time. Start painting from the top of the sky and point the corner of the brush which is loaded with paint towards the top of the scene. Make long, horizontal strokes for the sky. Smooth out any uneven areas, but do not work the sky too long or it will start to lift. The sky is always lighter at the horizon so use very little colour as you move down towards the land. Keep the sky colour off the banner.

Allow to dry. Repeat, if necessary, but make the sky colour light and transparent, allowing the cream base colour to glow through.

When the sky is thoroughly dry, mix Aqua and water to a runny wash, and glaze the sky area, starting from the top, and again working one panel at a time. If the Aqua wash is too intense, blot it with your cloth.

When the Aqua wash is dry, corner load the flat brush into Warm White and paint the clouds. The loaded corner of the brush

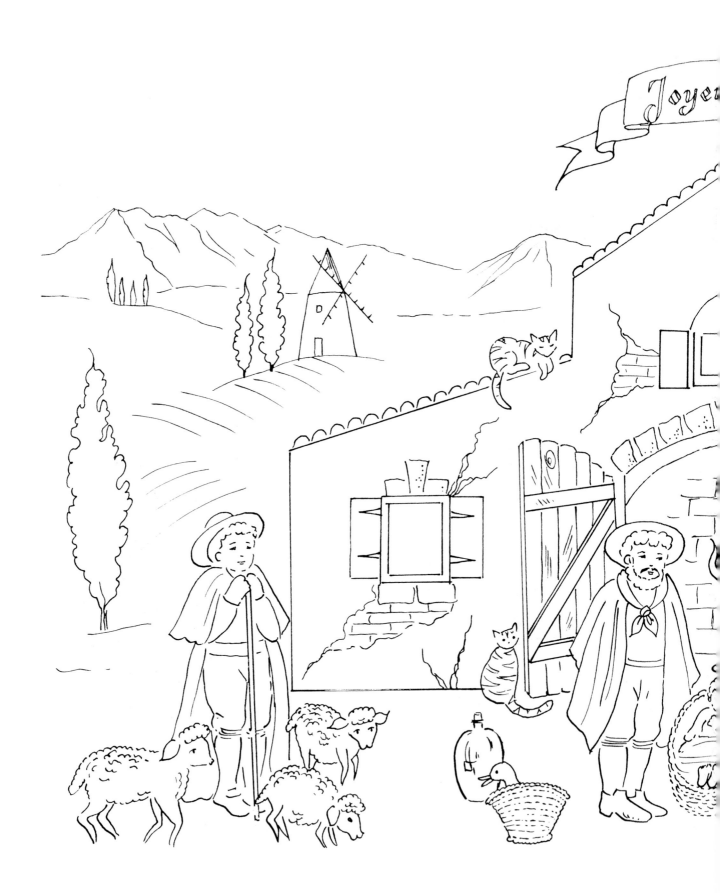

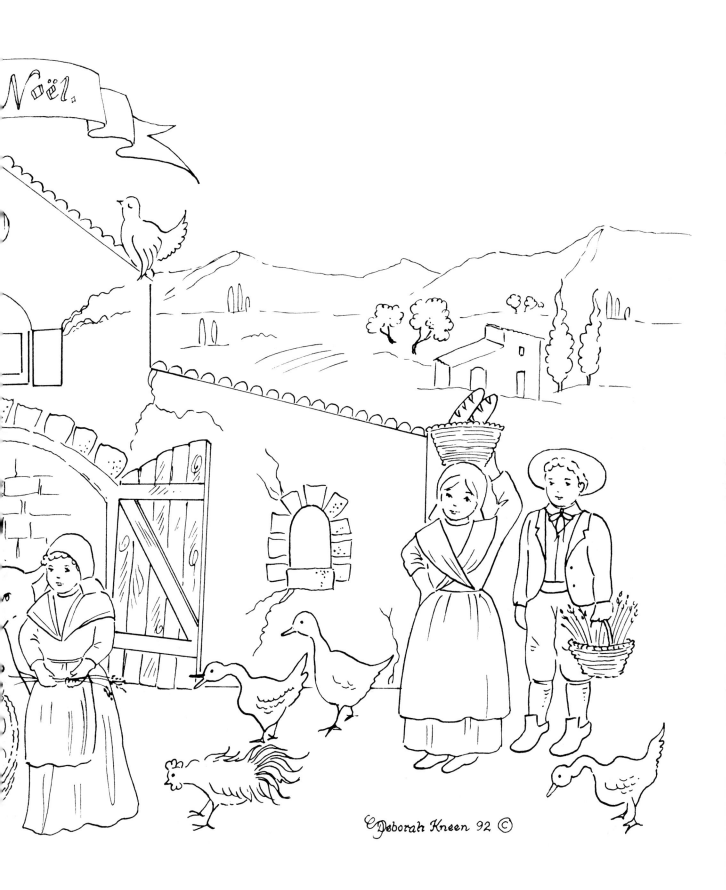

should face towards the top of the scene. Don't paint too many clouds or the sky will look cluttered. If the clouds appear too bright, let them dry and repeat the Aqua wash.

MOUNTAINS
Using the same technique we employed for the sky, pre-wet the mountains. Corner load the flat brush into Nimbus Grey plus a touch of Dioxazine Purple (on the same corner). With the colour facing the top of the mountains, float in the contours. When dry, make a wash with Gold Oxide and water and apply lightly to the mountains.

LAND
The contours of the land and fields are created with washes of colour. Keep the washes watery as you can always apply a second or third layer of colour, but it is difficult to remove colour which is too intense. If the colour looks too opaque, blot with a cloth and add more water to your brush. Let each wash dry before adding another layer over the top.

Washes for the land are applied with a No. 4 round brush. Use Moss Green, Gold Oxide and combinations of the two. Add some light washes of Pine Green plus Yellow Oxide over the field areas.

FIELDS
The rows of crops are created with the flat brush cornered into Moss Green plus Pine Green. Lightly float on the rows as indicated on the pattern. Make sure you cover the pattern lines.

CYPRUS AND OLIVE TREES
Use the No. 2 round brush, double-loaded with Moss Green and Pine Green. Paint consistency should be slightly watery but not as runny as a wash. Dab the paint on to create the texture of the foliage. Trunks are double-loaded Brown Earth and Nimbus Grey.

STABLES (*MAS*)
Shadows
Use the flat brush to float Gold Oxide plus Brown Earth around the edges of the stables, under the eaves and beside the doors. Use the photograph as a guide. With the same colour, float in the stone work around the windows and above the door. Float Brown Earth in each window, allowing a highlight of the cream base colour to show. Float Brown Earth and a touch of Carbon Black under the arch inside the stables. When dry, paint a wash

of Brown Earth over the entire arched interior, using the No. 4 round brush.

Sponged Stucco
Pre-wet the stables with water. With a slightly moist sponge, dip into Gold Oxide, wipe on a piece of paper, then lightly sponge the stables to create a stucco texture. When dry, repeat with Brown Earth and then Warm White. Keep the sponging subtle.

Shutters and Doors
Wash in these areas with Gold Oxide. When dry, add liner work detailing in Brown Earth. The stones are also outlined in this colour.

Roman Tiles
The roof tiles are outlined in Gold Oxide, using a liner brush.

WINDMILL

Float Brown Earth on one side of the windmill. The roof is a wash of Gold Oxide. Detailing is Brown Earth. Use the same techniques for the house on the right panel.

PEOPLE

Use a No. 2 round brush to paint the *santons'* clothing. The colour should be a little watery but not as thin as a wash.

Men's hats: Brown Earth plus Carbon Black or Black plus Pine Green.
Women's head-dresses and blouses: Warm White. Shade with Nimbus Grey.
Men's stockings: Nimbus Grey plus Warm White.
Shoes and boots: Brown Earth plus Carbon Black.
Faces and hands: Two coats of Flesh Colour.

Once faces are based in and dry, you can lightly transfer or sketch the facial features.

Add watery highlights of Warm White on the forehead, down the nose, at the top of the cheeks. Shade where the hair meets the forehead, using watery Gold Oxide.

All fine details are painted with a liner brush.
Facial features: Brown Earth.
Hair: Nimbus Grey or Brown Earth or Gold Oxide or a mix of Brown Earth and Gold Oxide.

SHEPHERD

Cloak: Pine Green. Shade with Pine Green plus Black to create folds.
Sash: Napthol Red.
Shirt: Turner's Yellow.
Breeches: Gold Oxide.

JOSEPH
Scarf: Napthol Red.
Shirt: Warm White.
Breeches: Carbon Black plus Pine Green.

MARY
Shawl and skirt: Napthol Red, shaded with Napthol Red plus touch of Carbon Black. Detailing on shawl and skirt: Turner's Yellow, Warm White, Pine Green.

BABY JESUS
Swaddling clothes: Warm White. Shade with Nimbus Grey.

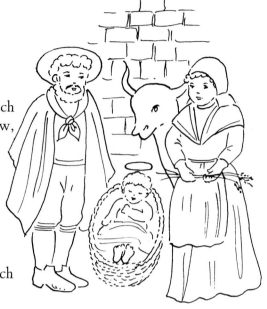

WOMAN WITH BASKET OF BAGUETTES
Shawl: Napthol Red with Turner's Yellow border.
Overskirt: Napthol Red, shaded with Napthol Red plus a touch of Carbon Black.
Floral motif on fabric: Warm White.
Underskirt: Gold Oxide plus Brown Earth. Shaded with Brown Earth.

MAN WITH BASKET OF LAVENDER
Shirt: Warm White.
Bow-tie and sash: Napthol Red.
Waistcoat: Pine Green plus a touch of Yellow Oxide.
Jacket: Pine Green plus Carbon Black.
Trousers: Brown Earth.
Lavender: Warm White plus Dioxazine Purple dots.
Stems: Pine Green plus Warm White.
 Float Brown Earth shadows under all the people.

ANIMALS
Once the animals are based in and dry, transfer or sketch the faces.

SHEEP
Base: Two coats of Warm White. Shade with Nimbus Grey.
Eyes: Carbon Black.
Nose: Flesh Colour.

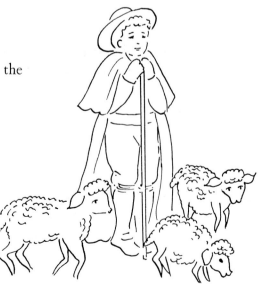

GEESE
Basing and shading: As for Sheep.
Beaks: Gold Oxide.
Eye: Carbon Black.

ROOSTER
Base: Two coats of Warm White.
Feather liner work: Nimbus Grey plus a touch of Carbon Black.
Comb: Napthol Red.
Beak: Gold Oxide.
Eye: Carbon Black.

DOVE
Base: Two coats of Warm White. Shade with Nimbus Grey.
Beak: Gold Oxide.
Eye: Carbon Black.

COW
Base: Brown Earth.
Horns: Nimbus Grey.
Eye and nostrils: Brown Earth plus Carbon Black.

CAT AT DOOR
Base: Gold Oxide.
Stripes and facial features: Brown Earth.

CAT ON ROOF
Base: Nimbus Grey.
Stripes. Nimbus Grey plus Carbon Black.

BASKETS AND JAR
Base: Gold Oxide.
Outline: Brown Earth.
Highlights: Warm White.

BANNER
The banner remains the original cream base colour. The lettering (Happy Christmas) should be carefully painted with a liner brush in Brown Earth. Shade the folds with Brown Earth. Outline the banner in Rich Gold.

FLOATED EDGE
Pre-wet the outside edges of the scene with water. Using the No. 10 or 12 flat brush, float Brown Earth around the edges. Use the photograph as a guide. Allow to dry. Repeat, if desired. Float Brown Earth under the banner. These shadowed edges add depth and a patina of age to the scene. The scene itself does not need to be antiqued. The underpainting technique and use of floated shadows bring unity to the piece by toning all the colours, making antiquing redundant.

ROUTED BORDER

The border is painted with two coats of Rich Gold (or experienced painters may choose to use gold leaf). When dry, float Brown Earth around the edge of the routing. Allow to dry, and then lightly float a little Aqua.

REVERSE SIDE OF TRIPTYCH

Paint the reverse sides of the panels Gold Oxide and then sponge-wash the surface with Brown Earth, Burgundy Red and Norwegian Orange. Float Brown Earth around the edges and trim with Rich Gold. A verse from the Bible (St Luke, Chapter II) is painted on the reverse side of the two side panels and is revealed when the triptych is closed:

C'est aujourd'hui, dans la ville de David, il vous est né un Sauveur, qui est le Christ, le Seigneur.

Gloire au Dieu au plus haut des cieux, et paix sur la terre aux hommes qu'il aime.

FINISHING

Varnish with two coats of water-based matte or satin varnish.

USEFUL INFORMATION

Window with lace panel, Chantilly

COLOUR CONVERSION CHARTS

NEUTRALS

General Colour Name	Jo Sonja's	Plaid FolkArt	Delta Ceramcoat	Deco Art Americana
BLACK	Carbon Black	Licorice	Black	Ebony Black
WHITE	Titanium White	Wicker White	White	Snow White
WARM WHITE	Warm White	Tapioca	Light Ivory	White Wash
FLESH COLOUR	Warm White + touch Napthol Red Lt + Yellow Oxide	Skintone	AC Flesh	Fleshtone
OPAL	Opal	Almond Parfait	Dresden Flesh	Flesh
SMOKED PEARL	Smoked Pearl	Vanilla Cream	Sandstone	Cool Neutral + Antique White
LIGHT GREY	Nimbus Grey	Barn Wood	Lichen Grey	Dove Grey
BLACK GREEN	4 parts Pine Green + 1 part Carbon Black	Wrought Iron	Black Green	Midnight Green

REDS, PINKS AND ORANGES

General Colour Name	Jo Sonja's	Plaid FolkArt	Delta Ceramcoat	Deco Art Americana
NAPTHOL RED	Napthol Red Lt + touch Burgundy	Red Clay	Tomato Spice	Country Red
BURGUNDY RED	4 parts Indian Red Oxide + 1 part Red Earth	Raspberry Wine	Burgundy Rose	Burgundy Wine
TERRACOTTA ORANGE	Norwegian Orange	Pumpkin Pie	Georgia Clay	Georgia Clay
CORAL PINK	Rose Pink	Ginger Snap	Fiesta Pink	Coral Rose
RED EARTH	Red Earth	Apple Spice	Red Iron Oxide	Red Iron Oxide

BROWNS

General Colour Name	Jo Sonja's	Plaid FolkArt	Delta Ceramcoat	Deco Art Americana
BURNT UMBER	Burnt Umber	Coffee Bean	Dark Brown	Burnt Umber
BROWN EARTH	Brown Earth	Maple Syrup	Brown Velvet	Mississippi Mud
GOLD OXIDE	Gold Oxide	English Mustard	Mexicana	Terra Cotta

YELLOWS

General Colour Name	Jo Sonja's	Plaid FolkArt	Delta Ceramcoat	Deco Art Americana
YELLOW OXIDE	Yellow Oxide	Harvest Gold	Antique Gold	Antique Gold
TURNER'S YELLOW	Turner's Yellow	Buttercup	Straw	Cadmium Yellow + Yellow Ochre
YELLOW LIGHT	Yellow Light	Lemon Custard	Luscious Lemon	Lemon Yellow
CREAM	Warm White + touch Yellow Oxide	Buttercrunch	Old Parchment	Yellow Ochre + Snow White

GREENS, BLUES AND PURPLE

General Colour Name	Jo Sonja's	Plaid FolkArt	Delta Ceramcoat	Deco Art Americana
PINE GREEN	Pine Green	Ripe Avocado	English Yew	Avocado + touch Ebony Black
DARK BLUE-GREEN	Teal Green	Plantation Green	Phthalo Green	Teal Green
MEDIUM BLUE-GREEN	Teal Green + Tit. White + touch Nimbus Grey	Blue Grass	Salem Green plus touch White	Blue Grass Green
LIGHT YELLOW-GREEN	Moss Green	Taffy plus touch Green Olive	Olive Yellow	Taffy Cream + touch Olive Green
ULTRAMARINE	Ultramarine	Ultramarine	Ultra Blue	True Blue
AQUA	Aqua	Aqua Bright	Laguna	Desert Turquoise
LIGHT GREY-BLUE	Tit. White + French Blue + touch Aqua	Summer Sky	Blue Haze	Salem Blue
PURPLE	Dioxazine Purple	Pure Pigment Dioxazine Purple	Purple	Dioxazine Purple

LOSSARY

armoire	(pronounced 'arm-wahr') large wardrobe.
camaieu	(pronounced 'carm-ah-yer') painting in different tones of the same colour (cf. *grisaille*).
carte	menu.
cartouche	(pronounced 'car-toosh') a fancy oval or rectangle border, often formed with a series of scrolls. Originated during the Renaissance.
ceramics	general term, encompassing all kinds of porcelain, terracotta, earthen and stoneware.
chinoiserie	(pronounced 'sheen-wars-er-ee') designs from, or inspired by, the Far East.
commode	chest of drawers.
décor à l'ancienne	(pronounced 'day-cor a lon-see-en') designs from the past.
décor folklorique	(pronounced 'day-cor folk-lor-eek') rustic folk art decoration, also known as *peinture paysanne* or peasant painting. The German equivalent is *Bauernmalerei*.
Empire furniture	furniture of the Napoleonic era, featuring neo-classical characteristics and often lacquered and decorated with gold.
faience	(pronounced 'fay-onse') earthenware covered with tin glaze i.e. lead glaze made opaque by the addition of tin ashes, and fired at a high temperature. Takes its name from the Italian town of Faenza. Preceded porcelain in Europe and is still being made today. Major centres for faience in France were Rouen, Nevers, Moulins, Moustiers, Montpellier, Nîmes and Marseilles.
faux finish	a painted finish which simulates a natural surface such as marble.
fleurs au naturel	naturalistic-looking flowers used in Strasbourg porcelain in the 18th century. Also known as *fleurs des Indes* (flowers of the Indies) or *fleurs fines* (refined flowers).
grisaille	(pronounced 'greez-eye') design painted in variations of grey. Found often in faience of the Midi and Mediterranean.
grotesques	figures appearing on porcelain, engravings, etc. Tend to be farmers, hunters, soldiers or travelling musicians. Popular characters in the faience of Moustiers and Rouen.
haut style	(pronounced 'oat steel') sophisticated style of painting, required refined artistic skills.

lacquer	used in the Far East and made with rhus tree resin which is filtered through cloth and then oxidised.
Martin Brothers	in the middle of the 18th century, the four *frères Martin* invented and patented a varnish which imitated authentic Chinese lacquer. Unlike real lacquer, however, it was not waterproof and tends to crack and yellow over time.
Moustiers	style of faience from the south of France, decorated naively with grotesque figures, rustic scenes, stylised flowers and simple ornamental borders.
nacre	(pronounced 'narc-r') mother of pearl, used to decorate 18th and 19th century furniture, particularly during the time of Napoleon III.
paravent	(pronounced 'par-a-von') screen.
placage	(pronounced 'plars-arj') wood veneering.
porcelain	vitreous ceramic. Developed in China in the 5th century and introduced to Europe in the 18th century. Major European centres for porcelain manufacture were Sèvres and Limoges in France and Meissen in Germany.
rocaille	(pronounced 'roc-eye') scroll.
Rococo	asymmetrical, flowery style of decoration, featuring scrolls and curves. Popular in the 18th century, and revived several times since.
Rouen	northern centre of faience, noted for its *style rayonnant*, a style that is typically Louis XIV. Used triangular motifs resembling festoons or swags which point towards the centre of a design. The motifs were painted blue on a white ground, or sometimes the reverse.
santon	(pronounced 'sonn-ton') hand-painted terracotta Nativity figures from Provence. Date back to 18th century.
santonnier	*santon* maker.
Second Empire Furniture	black lacquered furniture decorated with polychromatic flowers, porcelain inserts and encrusted with mother of pearl.
sécretaire	writing desk.
Sèvres	(pronounced 'sev-r') premier French porcelain manufacturer. Opened in 1756. Archrival of Meissen in Germany.
scène galante	Watteau style scene of lovers and cherubs in an idyllic setting.
sonnaille	(pronounced 'sonn-eye') cow bell.
tôle peinte	(pronounced 'tole pant') painted tinware.
tricolore	(pronounced 'tree-col-or') French flag: blue, white and red vertical stripes.
triptych	picture on three panels.
trompe l'oeil	(pronounced 'tromp ler-y') a painted composition, often a panel or mural, so photographically real it deceives the eye.
Versailles	(pronounced 'vair-seye') palace of Louis XIV, the Sun King. Decorated with painted wall panels and ceilings.

village perché (pronounced 'veel-arj pairsh-ay') literally 'perched village'. A village built on a hillside or clifftop.

Vincennes (pronounced 'van-sonn') palace where fine French porcelain was produced from 1745. In 1756 porcelain manufacturing was moved to Sèvres to be closer to the court and the protection of Louis XV.

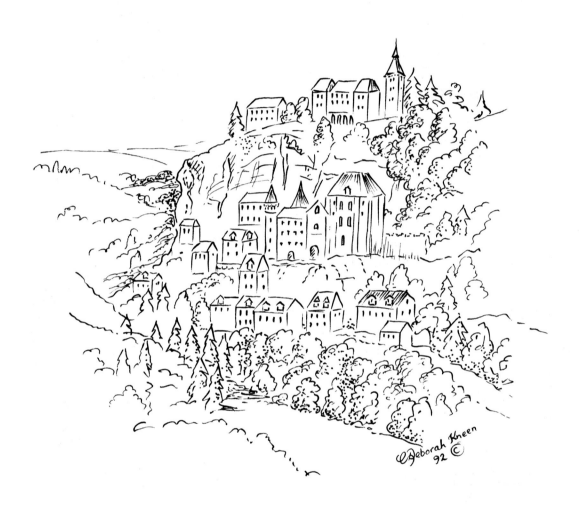

Borders and Cartouches

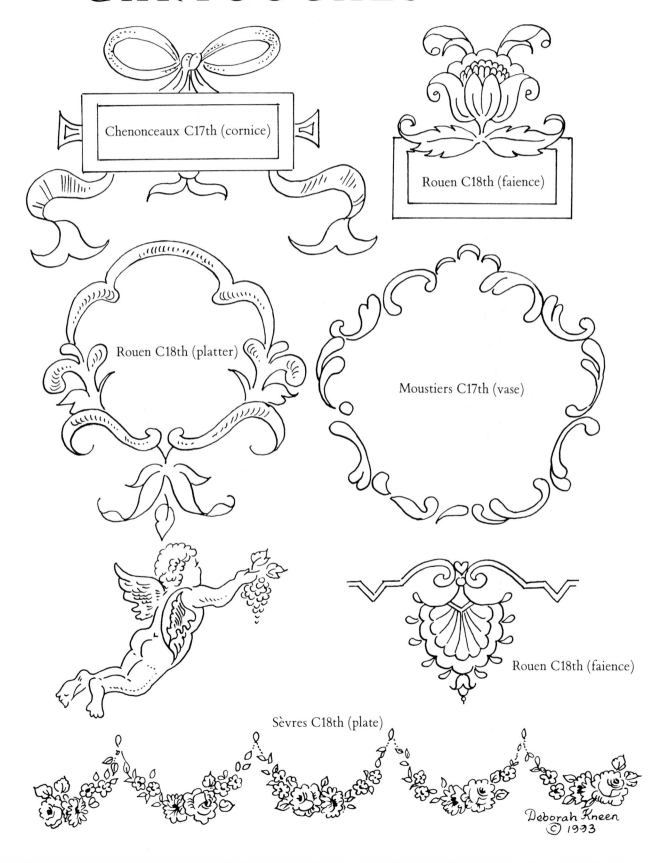

Chenonceaux C17th (cornice)

Rouen C18th (faience)

Rouen C18th (platter)

Moustiers C17th (vase)

Rouen C18th (faience)

Sèvres C18th (plate)

Deborah Kneen
© 1993

SOURCES:
PAINTING SURFACES

Lavender Pot (page 47): Terracotta pot, approximately 800 mm in top circumference, from garden nurseries and decorator shops.

Pepper Mill (page 50) This pepper mill is 400 mm tall. Wooden pepper mills are available from specialty kitchenware shops and department stores.

French Village (page 54): The Folk Art Studio, 200 Pittwater Road, Manly, NSW 2095, phone: (02) 977 7091, and folk art shops nationally.

Old Metalware (page 58): Metal items can be purchased at auction and from old wares and antique shops. New galvanised metal pieces from folk art shops and hardware stores.

Tricolore Trivet (page 63): Octagonal trivet 185 mm across. Use the pattern and cut from pine or Craftwood.

Dauphiné Cow Bell (page 67): Purchased in St Bonnet, France. Cow bells in varying sizes available from Bavarian Folk Workshop, 'Boronia Cottage', 53 Broughton Street, Camden, N.S.W. 2570, phone: (046) 55 2420.

Cutlery Box (page 71): 430 mm long, 280 mm wide, 135 mm high. Can be purchased raw or pre-stained. Project piece was pre-stained. Made by Jemima Farm Country Collectables. Available from Lugarno Craft Cottage, 243 Belmore Road, Riverwood, N.S.W. 2210, phone (02) 584 1944, and various other outlets nationally.

Wooden Shoes (page 83): Old shoe lasts from Appley Hoare Antiques, 55 Queen Street, Woollahra, N.S.W. 2025, phone: (02) 362 3045 and various secondhand and antique shops.

Menu Board (page 86): 475 mm high, 380 mm wide. Can be purchased raw or stained. Raw is best for this project. Made by Jemima Farm Country Collectables. Sources as for Cutlery Box above.

Coffee Grinder (page 93): Manufactured in Europe and available from Bexley Wholesalers, 36 Sarsfield Circuit, Bexley North, N.S.W. 2206, phone (02) 502 3526.

Set of Canisters (page 105): Your local ceramics studio will be able to supply a set of bisque canisters. Bisque ware will be white and matte in finish. It is fired to full strength but unglazed. Prior to painting, ask the studio to glaze and fire the insides of the canisters so that they can be used to store food.

You will find plenty of canisters with glazed exteriors but they are not suitable for painting with acrylics as the paint will not adhere properly to a shiny surface.

Savoie Clock (page 109): 420 mm high, 300 mm wide. Craftwood or pine. Available from folk art shops. Movement and hands available from The Folk Art Studio. (see above.)

Watering Can (page 116): 780 mm circumference, 250 mm high. Galvanised watering cans, ready to prime/seal and paint are available from folk art shops, garden nurseries, hardware stores and some decorator shops.

Provencal Triptych (page 122): 245 mm high, 385 mm wide. Wood piece courtesy of Monica Foltin-Rupprecht and Jo Sonja Jansen. Triptychs in varying sizes and shapes are available from folk art shops.

OURCES:
MUSEUMS

ALSACE-LORRAINE

Musée Alsacien, 23, quai St-Nicolas, Strasbourg. (Fine collection of painted furniture.)

Musée Historique Lorrain, 64, Grande Rue, Nancy. (Painted trunks and furniture.)

BERRY LIMOUSIN

Musée National Adrien-Dubouché, 8, place Winston-Churchill, Limoges. (Limoges and other porcelain.)

Le Pavillon de la Porcelaine, place David Haviland, Limoges.

ILE-DE-FRANCE

Fondation Claude Monet, ('Le Pressoir'), rue Claude Monet, Giverny (north-west of Paris, near Vernon).

LANGUEDOC-ROUSSILLON

Musée Fabre, boulevard Bonne Nouvelle, Montpellier. (Small but fine collection of ceramics.)

LOIRE VALLEY

Château de Chenonceaux, Chenonceaux (on the Cher River near Amboise).

NORMANDIE

Musée de la Céramique, 1, rue Faucon, Rouen. (Rouen faience ware of the 16th through 18th centuries.)

PARIS

Musée des Arts Décoratifs, Palais du Louvre, 107, rue de Rivoli, 1er, Paris. (Extensive collection of ceramics.)

Musée National de Céramique de Sèvres, Place de la Manufacture, Sèvres, 7e, Paris. (Paris suburb.) (Superb porcelain and faience collection.)

PROVENCE

Musée de Vieux-Marseille, Maison Diamentée, 2, rue de la Prison, Marseille. (*Santon* collection, ceramics.)

Musée d'Art d'Histoire de Provence, Hôtel de Clapiers-Cabris, 2, rue Mirabeau, Grasse.

Musée de Vieil Aix, 17, rue Gaston de Saporta, Aix-en-Provence. (*Santons*, painted screen, ceilings.)

Muséon Arlaten, 29, rue de la République, Arles. (Important collection of Provençal folk arts: furniture, ceramics, utensils.)

Musée de Vieux Nîmes, Place de la Cathédrale, Nîmes.

SAVOIE-DAUPHINE

Musée des Charmettes, rue Jean-Jacques Rousseau, Chambéry (outside town). (Country house of Jean-Jacques Rousseau — painted panels, faux finishes.)

Musée Dauphinois, 30, rue Maurice-Gignous, Grenoble. (Folk arts and crafts of the Dauphiné.)

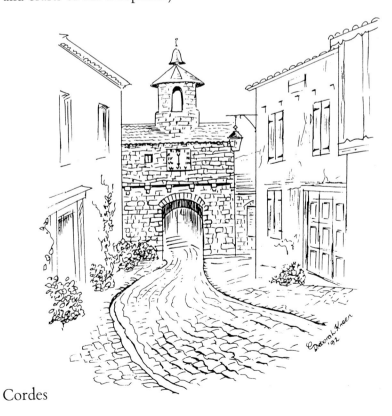

Cordes

BIBLIOGRAPHY

DECORATED WOOD AND CERAMICS

Alexiev, Dony, *Décors sur Porcelaine*, Dessain et Tolra. (Instructional book with history of porcelain designs.)

Avon-Coffrant, Françoise, *Manuel Pratique de la Peinture sur Bois*, Celiv. (History of painting on wood, including contemporary French hand-painted furniture.)

Binski Paul, *Les Artisans du Moyen Age: Les Peintres*, Brepols. (Church painters of the Middle Ages and their works.)

Charleston, Robert J. (ed.), *World Ceramics: An Illustrated History*, Crescent Books.

Jansen, Jo Sonja, *Painted Decoration Volume 1*, Jo Sonja's Folk Art. (Beautiful soft French provincial florals on a variety of furniture and collectables.)

Lambert de Lacroix, Marianne, *Manuel Pratique de la Peinture sur Porcelaine*, Celiv. (Instructional book, plus excellent history of porcelain designs.)

Racinet, Albert, *The Encyclopaedia of Ornament*, The Studio Library of Decorative Art, Studio Editions.

FRANCE

Documents et Civilisation: Les Français et la France d'Aujourd'hui, Classiques Hachette.

Guides Michelin (green), Michelin

Forestier, Louis, *Panorama du XVIIe Siècle*, Editions Seghers.

FRENCH ANTIQUES AND COLLECTABLES
(Journals)

Beaux Arts.

Connaissance des Arts.

L'Estampille-L'Objet d'Art.

France Antiquités.

Trouvailles.

FRENCH CUISINE

Montagne, Prosper, *New Larousse Gastronomique*, Hamlyn.

SANTONS

Petit Dictionnaire des Santons de Provence (anonymous).

Les Santons de Marcel Carbonel (anonymous).